Then & Now
LORTON

Then & Now
LORTON

Yoshie Lewis

Published by Arcadia Publishing
Charleston SC, Chicago IL, Portsmouth NH, San Francisco CA

Printed in Great Britain

Library of Congress Catalog Card Number: 2005924319

For all general information contact Arcadia Publishing at:
Telephone 843-853-2070
Fax 843-853-0044
E-mail sales@arcadiapublishing.com
For customer service and orders:
Toll-Free 1-888-313-2665

Visit us on the internet at http://www.arcadiapublishing.com

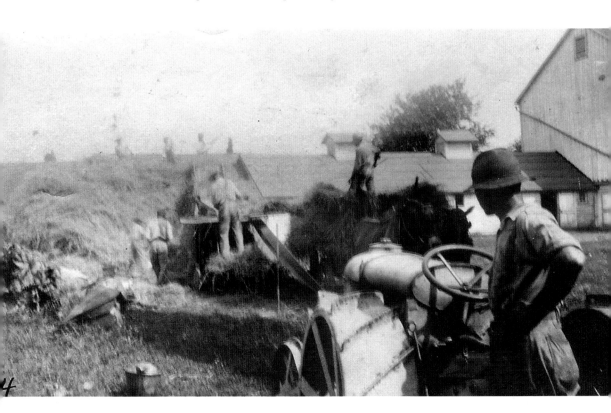

4

FARM WORKERS TOIL, 1920. African Americans were a vital part of the development of the Lorton area, long before it was called by that name. From everyday needs to the commercial enterprise of tobacco, the hard work of their hands helped to shape the community. (Courtesy Gunston Hall.)

CONTENTS

Acknowledgments

This book is the product of many contributors. Without their gracious aid and generosity, it would not have been made. Special thanks to Kyle Bacon; Gladys Bushrod; Irma Clifton, editor with the *Lorton Chronicle*; Cranford Memorial Church; Gunston Hall; Kevin Shupe, librarian; Library of Congress; Lorton Fire Department; Lorton Library; Denise Morgan, librarian; Martha Roberts of Historic Occoquan, Inc.; National Archives; Norvapics; Pohick Church; Trainweb.com; Fairfax County Library Virginia Room; and Brian Conley, librarian. (All "now" photos are by the author, except where noted.)

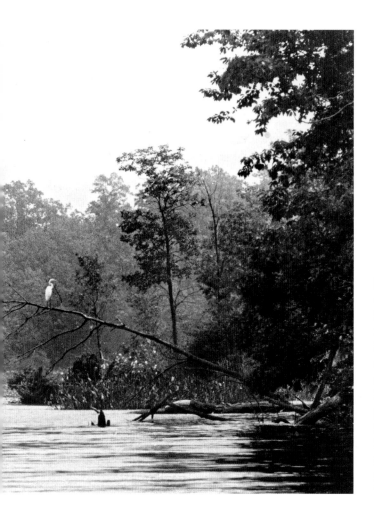

EGRET, MASON NECK, 1960s. The waterways here were traveled by the Dogue Indians, who probably occupied the area as early as the 14th century. In 1608, John Smith mapped this part of the Potomac, noting that the tribe contained about 135 people. Once European diseases caused the Dogue population to decline, the English took over the abandoned villages. Mason Neck is now a wildlife refuge preserved for future generations. (Courtesy Fairfax County Library Virginia Room.)

INTRODUCTION

At the outset of this project, it became apparent that nobody, the author particularly, seemed to know exactly where the boundaries of Lorton begin and end. We all know about the prison because the *Lorton Chronicle* frequently mentions some development of the former prison property. Since moving to Lorton just over a year ago, I have noticed the occasional peculiar response to my mentioning where I live. Such is the stigma surrounding the correctional facility established here in the early 20th century by Teddy Roosevelt. The prison complex is closed, but the negative sentiment associated with it remains.

Surely there must be more to Lorton, I thought. Some time back, looking for a quick Sunday outing, I looked up Pohick Church online and made a quick jaunt to it. My companion and I were surprised to learn that it was designed, in part, by George Washington. Frankly, we were surprised that such a thing existed here. We, too, were under the impression that all that comprised Lorton was the prison and the creepy little staff houses surrounding it. After all, it was here for almost 100 years. Who would have wanted to be here?

But there is a deep and rich history that precedes the institution. It begins in the 17th century. Adjacent to Mason Neck, between the Accotink and Pohick Creeks, once lay a village called Tauxenant, discovered by none other than John Smith. As I view the woods behind my pre-fabricated apartment complex, I cannot help wondering if the famous explorer once trekked across the land beneath it. Incidentally, I found a photograph of a farm house noted with an address on my street. I am pretty convinced the apartments are sitting on that property. We cannot locate the number, and the street is just two blocks long.

As I delved deeper, I discovered that several small towns in Fairfax County had completely disappeared. One such town was Colchester, from which only one building is known to exist. What was Colchester is now part of Lorton.

The Mason Neck/Gunston Hall area also is part of Lorton. The Bill of Rights was penned by the original owner of Gunston, George Mason. Much of our early history and the founding of our country was discussed behind the closed doors of his Georgian mansion.

I also elected to include in the book historic Occoquan, because its residents depended on the mills and waterways of the Lorton area.

Lorton proper was established in 1875 by an Englishman, Joseph Plaskett, who named it for his home in Cumberland County, England.

Much of what little historic fabric is left in Lorton quickly is being replaced with new housing developments and all that comes with them, including shopping centers, schools, and a new water plant. I am fortunate to have found archived photographs of Lorton.

I live in a community that seems to value appearance above all. For example, a contingency of residents would have Lorton's name changed to Laurel Hill in an attempt to erase the community's association with the prison. Lorton may become another town that was.

It will, then, be my endeavor to compile from many collections the story of Lorton, then and now, before now becomes then, and then is no more.

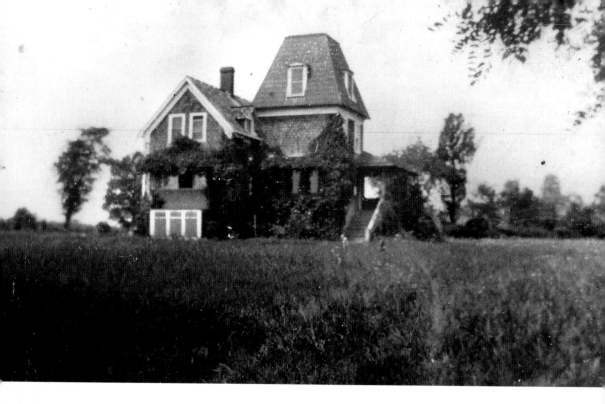

HYDE HOUSE, LATE 1960s. Sadly already lost from history, this intriguing home once graced Colchester. (Courtesy Fairfax County Library Virginia Room.)

Chapter 1

OCCOQUAN AND COLCHESTER

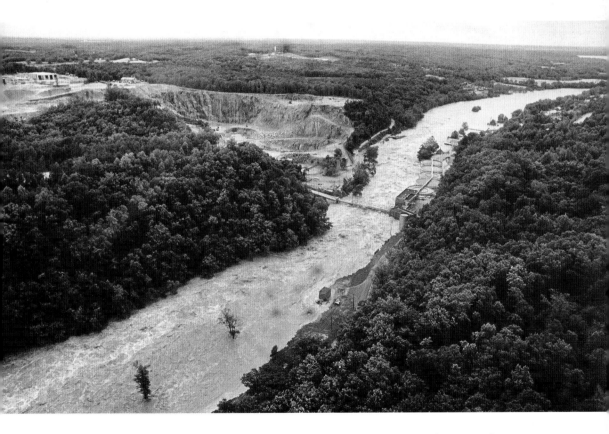

OCCOQUAN RIVER AERIAL VIEW, C. 1970. The quarry is on the left and the town of Occoquan on the right. Occoquan was established in 1759, when John Ballendine built the Merchant's Grist Mill, a vital part of Lorton's development. Occoquan survived ups and downs, while Colchester was not so lucky. The land that became Colchester was patented in 1666 and passed through various owners until it came to Peter Wagener, who established the town in 1753. It became a major tobacco port and stop along the King's Highway, named for "King" T. M. Carter. Colchester later declined around the dawn of 18th century and is now a part of Lorton. (Courtesy Fairfax County Library Virginia Room.)

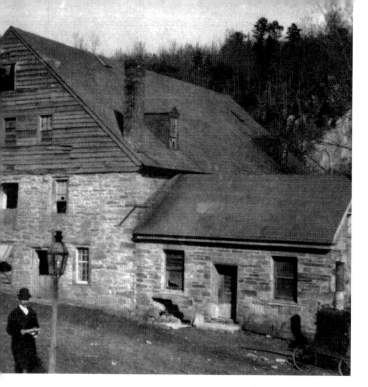

MERCHANT'S GRIST MILL, C. 1885, AND MILL OFFICE MUSEUM, 2005. John Ballendine built the Merchant's Grist Mill in 1759. It was the first automated gristmill in the nation. So impressed was George Washington that he consulted Ballendine regarding the design of his own mill. Seated to the right in the photo below is the granddaughter of the town and prison doctor, Frank W. Hornbaker. (Courtesy Martha Roberts, Historic Occoquan, Inc.)

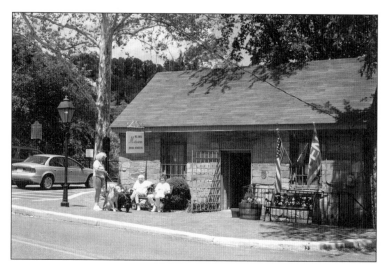

LOADING GRAIN INTO MILL, C. 1900. From John Ballendine, the mill passed into the possession of Nathaniel Ellicott. It continued in operation until 1924, when it was destroyed in an accidental fire sparked next door at the Occoquan Light and Power Company. (Courtesy Martha Roberts, Historic Occoquan, Inc.)

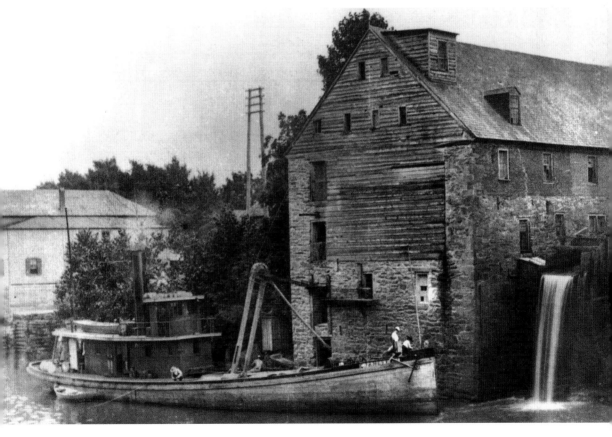

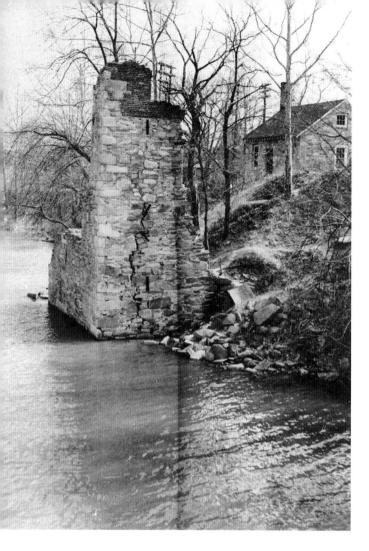

MILL REMAINS, C. 1970. The remains of the Merchant's Grist Mill were washed away by Hurricane Agnes in 1972. The mill office is all that remains, and it houses the Occoquan Museum. (Courtesy Library of Congress.)

ROCKLEDGE, 1970S. During the 1750s, John Ballendine, founder of the mills at Occoquan, had an 11-room house called Rockledge built. The site was carved out of a rock ledge, with stone supplied by a nearby quarry. William Buckland, who also built Gunston Hall for George Mason, is believed to have built the structure for Ballendine. The house has had four owners. The fourth left the house in 1960 because the nearby quarry blasting was loosening the building's foundation. Restored to its previous glory by Donald L. Sonner in the 1970s, Rockledge was burned by an arsonist in 1980. Present owners Joy and Ronald Houghton purchased the home in 1983 and again restored it. They added a 1770s-style ballroom in 1996. In addition to living in the house, they use it to host events such as weddings. (Courtesy Library of Congress.)

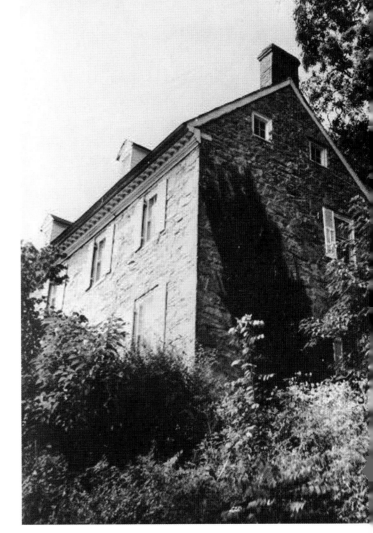

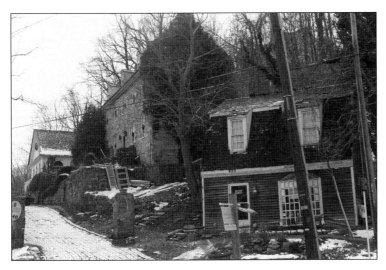

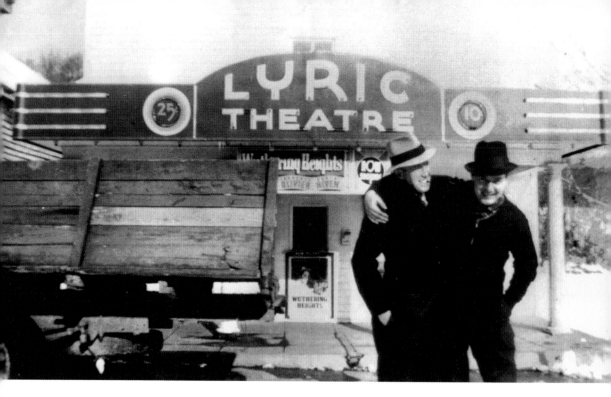

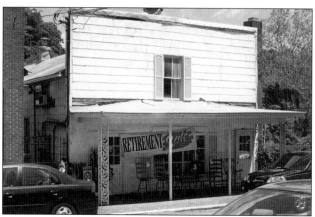

HAROLD WILCHER AND FRIEND, LYRIC THEATRE, C. 1940, AND BROWN'S STORE, 2005. The theatre was opened in 1920 by Frank Hornbaker, also the town doctor. It began with silent films but soon moved on to "talkies." In 1950, one could catch a show for just 20¢ for a child and 40¢ for an adult. (Courtesy Martha Roberts, Historic Occoquan, Inc.)

REAR OF LYRIC THEATRE, C. 1910. Frank Hornbaker is seen below in the boat behind the Lyric Theatre, the first building to the right. In addition to staying busy with the town's health and the theatre, the doctor loved to entertain on his boat. (Courtesy Martha Roberts, Historic Occoquan, Inc.)

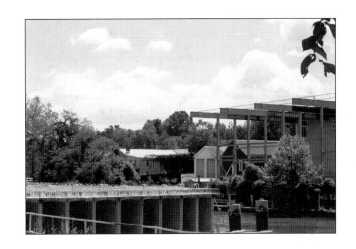

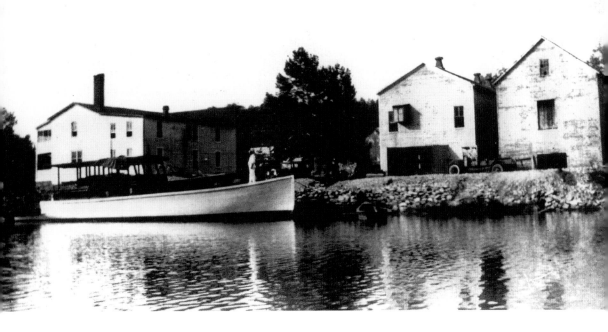

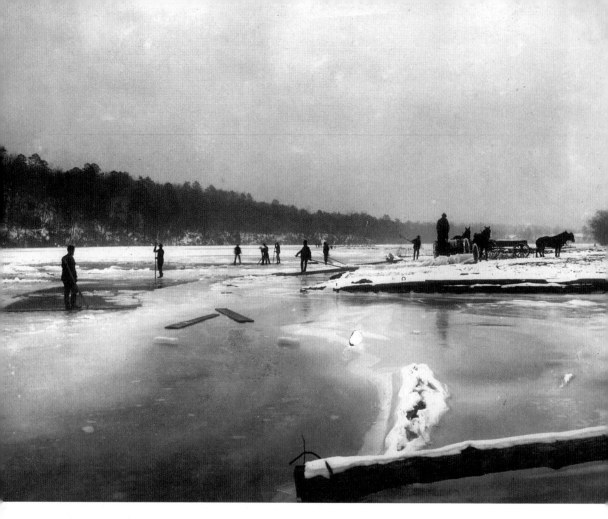

**CUTTING ICE ON THE OCCOQUAN,
c. 1900, AND ICE BOX, 2005.**
The first commercial ice storage
house in the area was located here.
Ice was harvested and stored for
shipment to Washington, D.C., in
the summertime. Reports in 1917
indicated that the ice was 26 inches
thick. Only small sheets of ice form
in the winters now, hardly enough to
bear a man's weight. It is much easier
to step out back to the ice machine.
(Courtesy Martha Roberts, Historic
Occoquan, Inc.)

BAPTISM IN OCCOQUAN, *C.* 1900, AND EBENEZER CHURCH BUILDING, 2005. The church was founded in 1883 by the Reverend Henry Bailey, a former slave. Rebuilt in 1924 after a fire, the building is now used for various functions, including Korean church services. The church body meets in the Telegraph and Minnieville Roads area. Members of Reverend Bailey's family are still active in the congregation today. (Courtesy Martha Roberts, Historic Occoquan, Inc.)

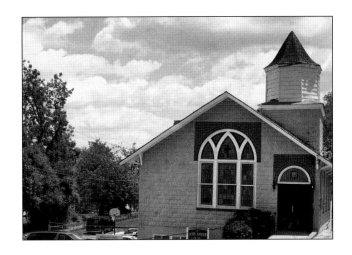

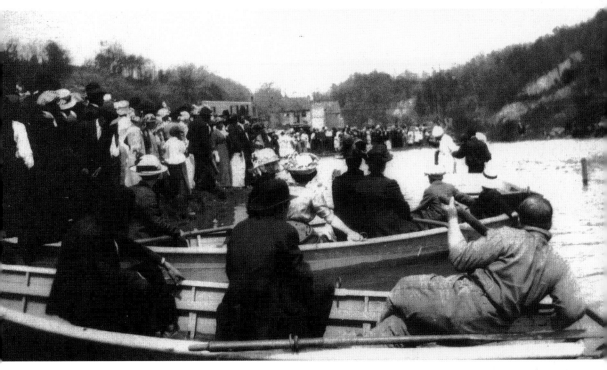

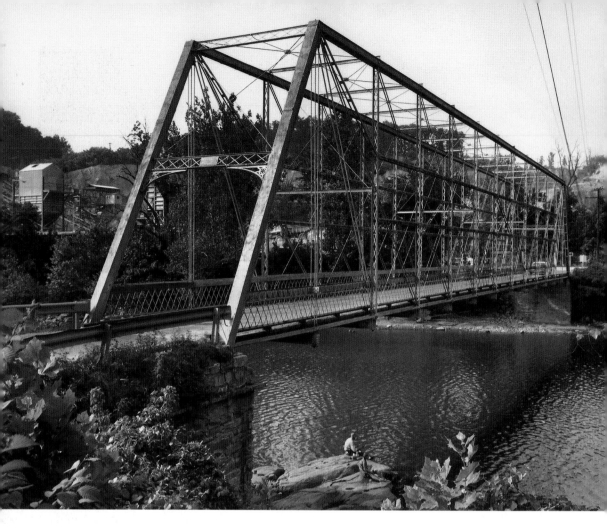

PRATT TRUSS BRIDGE, 1970, AND OCCOQUAN BRIDGE, 2005. Prior to the Civil War, a toll bridge existed on the main thoroughfare between Richmond, Virginia, and Washington, D.C. Union troops burned the bridge, built in 1795. The Pratt truss bridge was built in 1878 and used until 1972, when it was washed away by Hurricane Agnes. A new bridge was built on Ox Road and was undergoing massive expansion in 2005. (Courtesy Fairfax County Library Virginia Room.)

MILL STREET, C. 1953. This is the view of the street from the end of town where the mill was located. Just out of the frame to the right is Rockledge and to the left is the mill office. The Lyric Theatre, now Brown's Woodstuff, is about half a block away on the left. Brown's Woodstuff is a family-owned and -operated store selling solid wood furniture with locations in Occoquan, Manassas, and Warrenton. (Courtesy Martha Roberts, Historic Occoquan, Inc.)

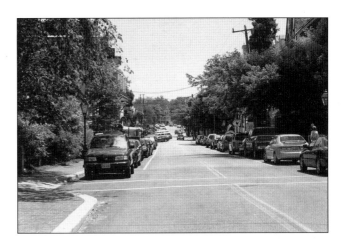

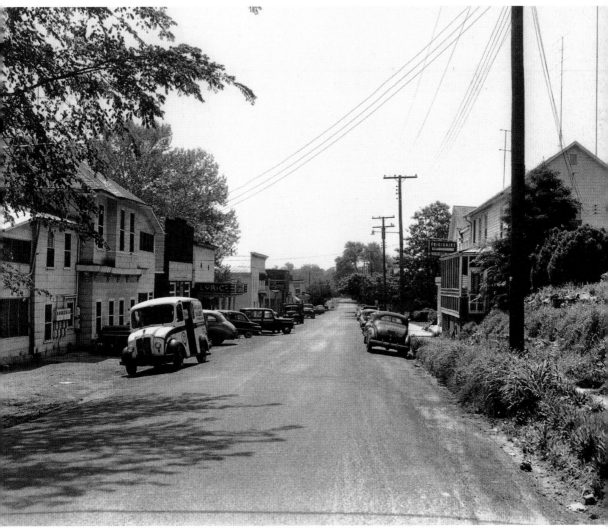

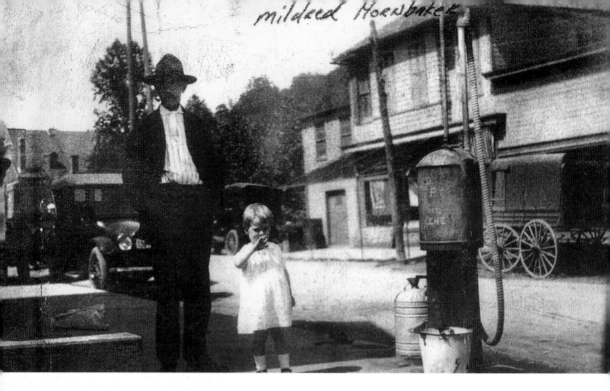

mildred Hornbaker

GAS STATION, 1918, AND GARDEN KITCHEN, 2005. No gas stations are in the old-town part of Occoquan today, but many pedestrians remain. The street has a more polished look where the station once stood. (Courtesy Martha Roberts, Historic Occoquan, Inc.)

BLACKBEARD'S, C. 1970, AND GOLDEN GOOSE, 2005. The owner of Blackbeard's, Donald L. Sonner, had to close his business for a time following an electrical fire. Soon after that, his home, Rockledge, fell victim to arson. To make matters worse, the front of the building was struck by a boat floating down the street after Hurricane Agnes. The damage from that incident is visible on the right door jam. The building now houses the charming Golden Goose. (Courtesy Martha Roberts, Historic Occoquan, Inc.)

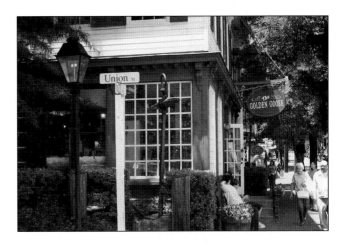

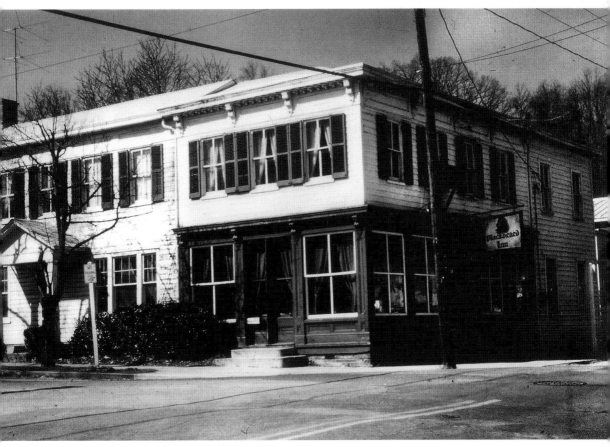

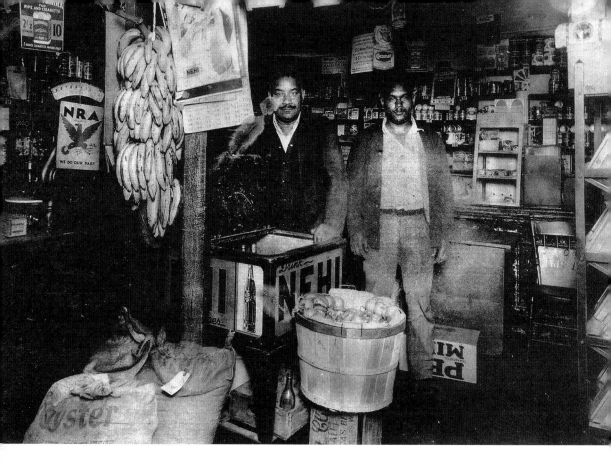

OGLE HARRIS STORE, C. 1940, AND TREASURE HUNT, 2005. Ogle (left) and Arthur Harris are pictured in their store. Ogle Harris began his enterprise by selling hand-cranked ice cream at the Odd Fellows Hall. When his family moved into a larger home, he turned the old house into a store. It was an Occoquan institution from about 1910 until 1972. (Courtesy Martha Roberts, Historic Occoquan, Inc.)

METZGER HOUSE, 1923 (BOTTOM) AND 1970 (TOP). Established in 1753, Colchester played a significant part in the area's development as a center for tobacco trade and commerce on the Occoquan River. The town was built on a tract of land owned by Peter Wagener. In its heyday, Colchester boasted 40 houses, but by 1835, just two remained, including the Metzger house. Because of its many alterations, this house was not eligible to be saved as a historic site and was demolished in the 1970s. Today, Colchester is linked to the Lorton community as a residential area, with little to remind one of the thriving commercial center it once was. (Courtesy Virginia Room, Fairfax County Library.)

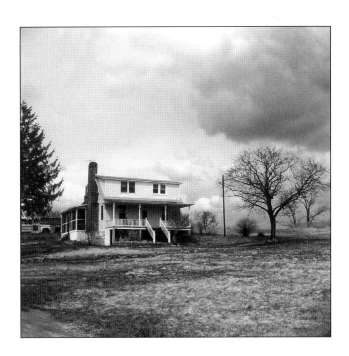

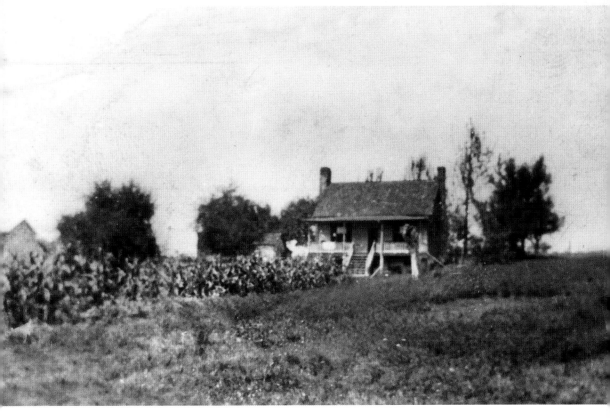

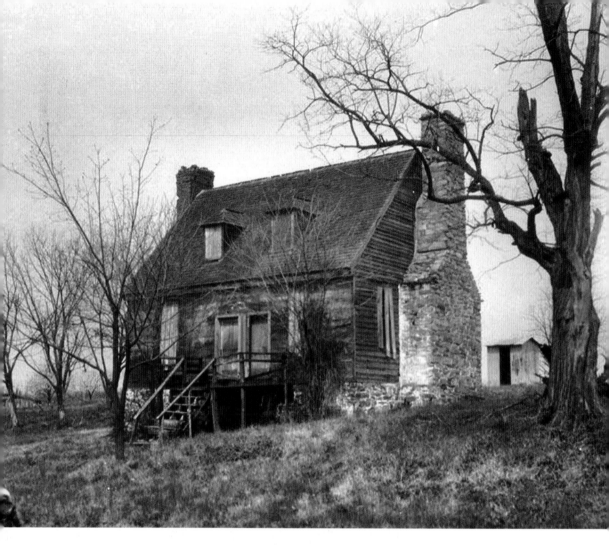

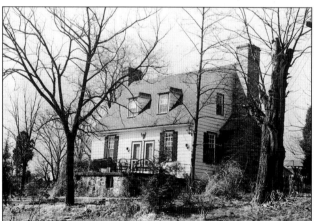

FAIRFAX ARMS, 1940S AND 1960S.
The structure was built in 1750, and in 1756, owner Benjamin Grayson went bankrupt. Three lots were advertised for sale, and one included a "dwelling suitable for an ordinary." Once called the Colchester Inn, the Fairfax Arms was a popular stop along the King's Highway, once a Native American trail that traversed the countryside from Philadelphia to Williamsburg. It was quoted that every luxury one could desire could be had at the Arms. In 1954, it came into the possession of the Duncan family, which contributed to its ongoing preservation. (Courtesy Library of Congress.)

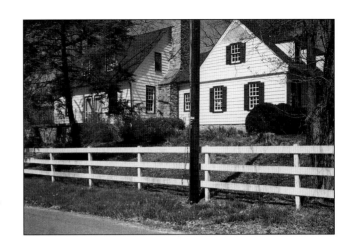

FAIRFAX ARMS, 1940s. The Fairfax Arms not only was a popular place for travelers but for the local vestry from Pohick Church, including notable members George Washington and George Mason. The present structure maintains the integrity of the historic house under the care of loving owners, who boast a tasteful additional wing. (Courtesy Library of Congress and Arms owners.)

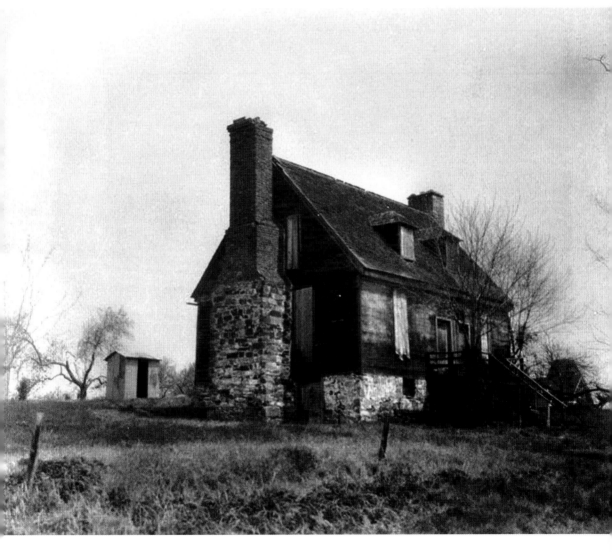

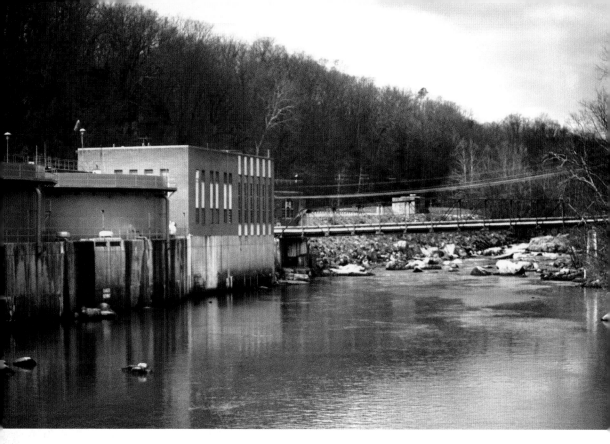

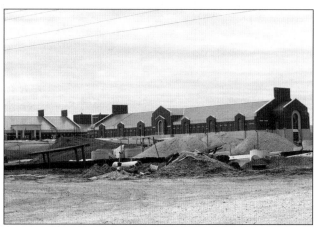

OCCOQUAN WATERWORKS, 1990S.
The Occoquan Waterworks is slated
to shut down with the opening of the
new, expansive Lorton Waterworks.
Plans for the area include removal
of the equipment to make way for
a public park. The Lorton facility
is located where the Occoquan
Workhouse at the Lorton Prison
Complex once stood.

Chapter 2

CHURCHES

POHICK CHURCH, 1930s. The first Pohick Church was located at the site of Lewis Chapel, on land owned by the Mason family. In 1765, as the building began to need major repairs, the vestry, including George Washington and George Mason, deliberated over moving the church to a more central location. Washington favored the move, Mason did not. The move happened, and a new building was built, with Washington contributing to its design. The ravages of the Civil War, along with a decline in the popularity of the Episcopal Church in America, spurred decay and damage to the structure. In 1930, the building was finally restored to a semblance of its original style and splendor. Churchgoers can see names etched on the doorpost by soldiers of a bygone era. (Courtesy Pohick Church.)

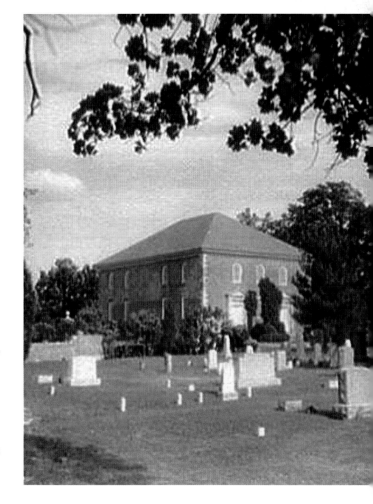

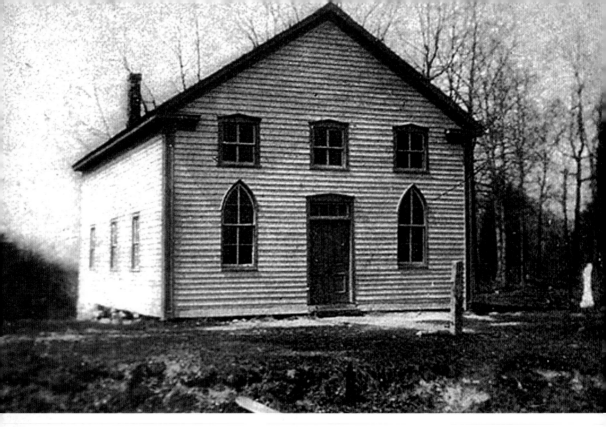

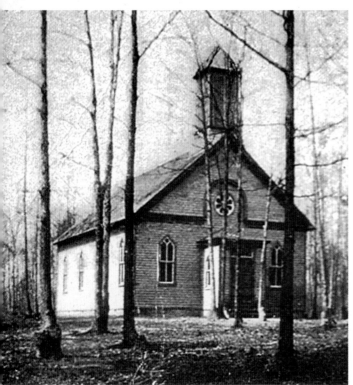

LEWIS CHAPEL, 1857, AND CRANFORD MEMORIAL CHURCH, c. 1900. Methodism came to the area around 1830 with meetings at the Lebanon Farm. In 1857, the first Methodist church was built largely by James and John Cranford. It was named Lewis Chapel. With the continued growth of the congregation, more space became necessary, and on June 9, 1901, a new building was dedicated nearby and named Cranford Memorial Church. (Courtesy Cranford Memorial Church and Irma Clifton, *Lorton Chronicle*.)

CRANFORD MEMORIAL CHURCH, C. 1950 AND C. 1960. In December 1953, Lewis Chapel was moved to a location adjacent to Cranford Memorial Church, under the supervision of architect Hayward Davis. Today the church ministers to a continually growing body. (Courtesy Cranford Memorial Church.)

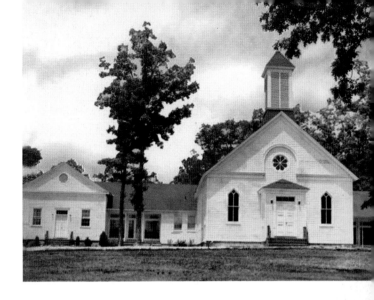

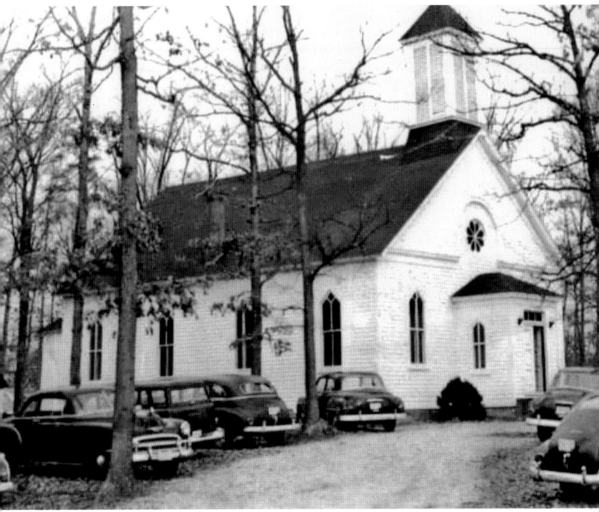

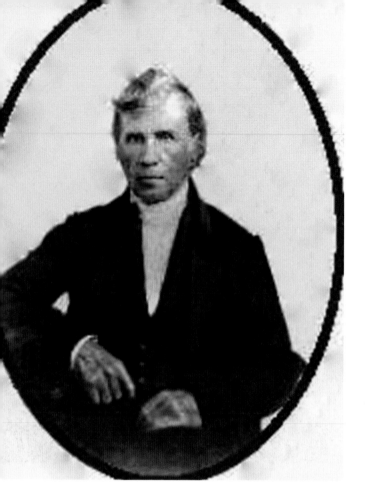

THE REVEREND JOHN LEWIS, LATE 19TH CENTURY, AND CRANFORD MEMORIAL CHURCH, C. 2003. Reverend Lewis arrived in the Gunston Hall area to find a growing need for a Methodist church. From Lebanon Farm, they moved meetings to the Pohick Church, and in 1857, Lewis Chapel was built, named for John Lewis. After many additions and changes to the church building, the parking lot was expanded and paved in the late 1980s, and the steeple is being restored to its previous glory. (Courtesy Cranford Memorial Church.)

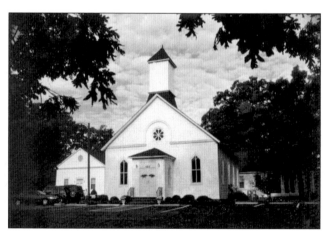

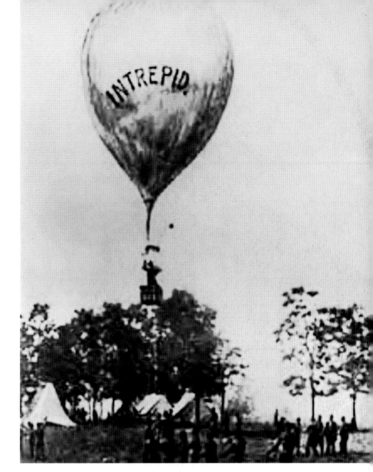

THE *INTREPID*, 1862, AND POHICK CHURCH, 2000. In March 1862, Prof. Thaddeus S. C. Lowe, chief aeronaut in the U.S. Army, was ordered to take the hot air balloon *Intrepid* to Pohick Church for repairs and reconnaissance. During the Civil War, the church sustained much damage, including having names carved in the doorpost. (Courtesy Pohick Church.)

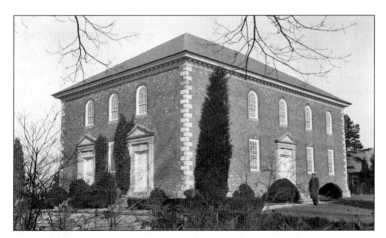

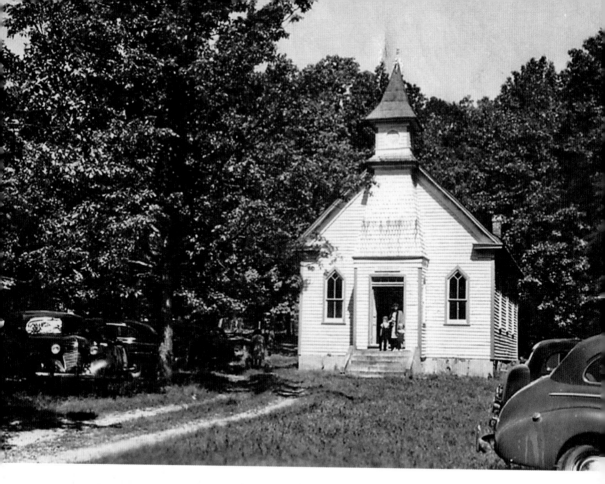

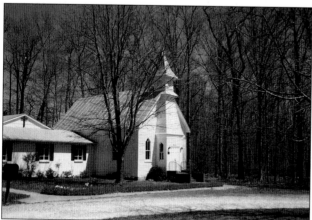

SILVERBROOK UNITED METHODIST CHURCH, 1930s. The original church, which contains a sanctuary, was built between 1906 and 1908 and is on the National Register of Historic Places. The landscape of the church property essentially remains unchanged. On the southwest side, the prison farm field across the road has not changed since the church was built. The church always has had either a dirt or gravel driveway, which has helped keep a wonderful charm about the property. The wooded land adjoining the property has stayed intact as well. The church originally was part of a rural farm setting. Now the site it occupies is an oasis of the past amid a changing suburban environment. (Courtesy Irma Clifton, *Lorton Chronicle*.)

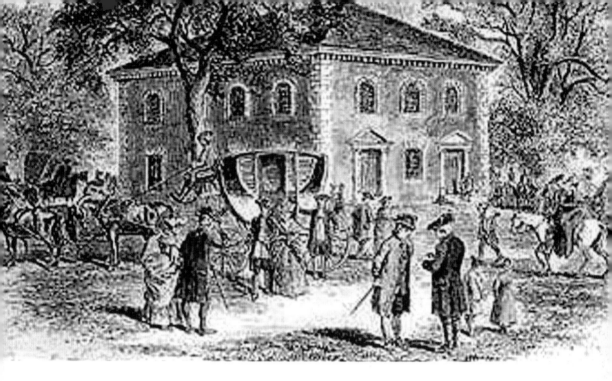

Pohick Church, Late 18th and Early 19th Centuries. Pohick is seen as it looked in its early days, when parishioners such as the George Washington family and George Mason attended. It was periodically abandoned in the early 19th century and is depicted in a dilapidated state, overgrowth with weeds, by American artist John Gadsby Chapman.

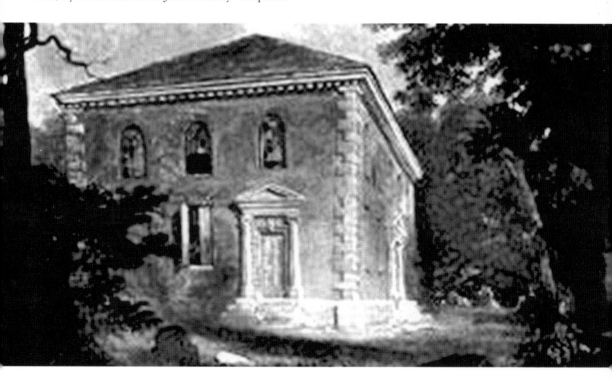

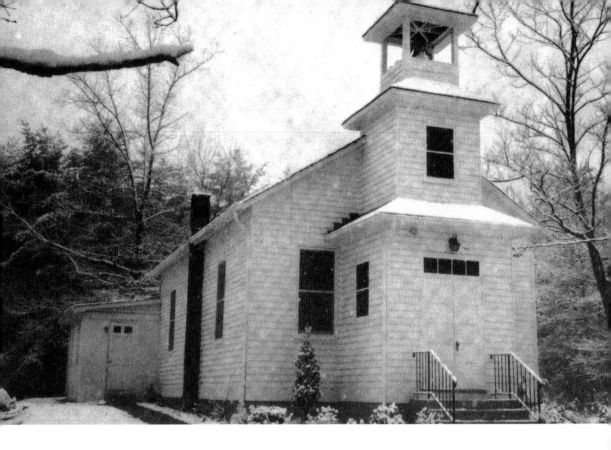

SHILOH BAPTIST CHURCH, 1969. Before plans were established in 1869 to build a church here, African Americans from the area walked to Alexandria to worship. Shiloh's first services were held in the log cabin owned by Col. Edward Daniels of Gunston Hall. That same building was also used for the first school for black children. It burned to the ground, and in 1900, the church body purchased the original Gunston School for white children. Prior to 1950, baptisms were performed in the Potomac River, as there was no baptistery in the church building. Through the years, many changes were made to the structure, with a new sanctuary dedicated in 1985. The mortgage was paid off in only nine years by the approximately 40 members of the congregation. (Courtesy Mrs. Gladys Bushrod, 96-year-old member of Shiloh.)

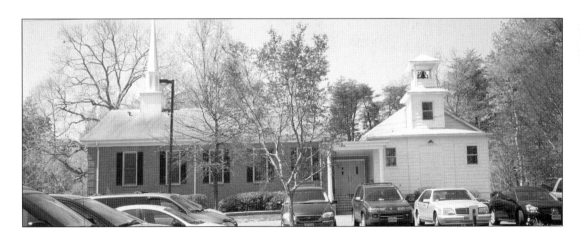

Chapter 3
COMMERCE

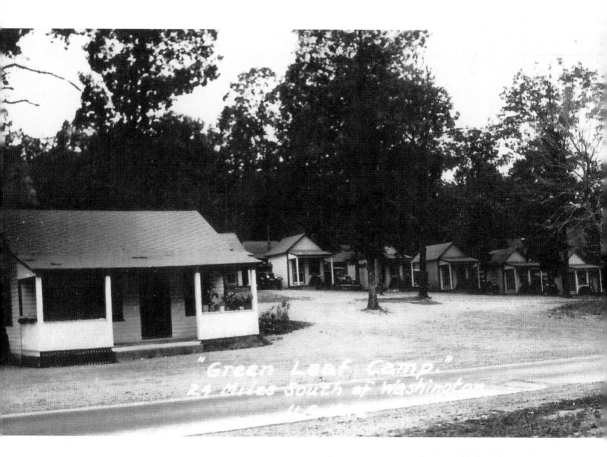

GREENLEAF CAMP, C. 1940s. This was not a camp but a popular motel for locals as well as travelers. It was owned by the Brown family and was located on Route 1. Also called Richmond Highway, Route 1 was established on an old Native American trail named Potomac Path by the settlers. It was located where the road now divides at the entrance to Interstate 95. (Courtesy Norvapics.)

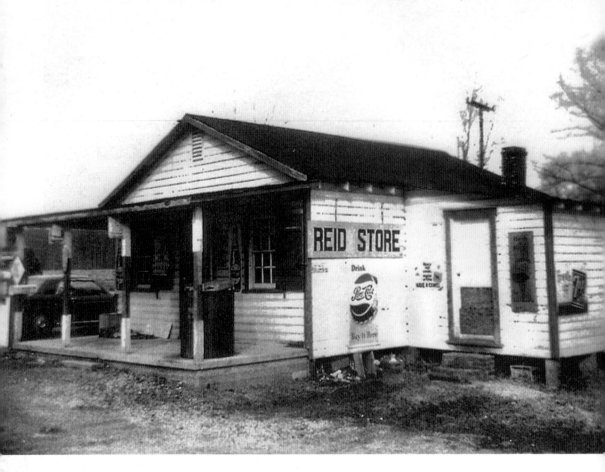

REID STORE, 1969. The store was built in the 1920s. Earl Reid's mother ran this store until she was in her 80s. Her son followed suit, until his Alzheimer's forced him to enter a nursing home and sell the store. With the widening of Ox Road (Route 123), the building was demolished. (Courtesy Irma Clifton, *Lorton Chronicle*.)

FOREST INN AND HELMS STORE, *c.* **1940.** Typical of the era, one could carry a tab at this store. The owner's son, Percy Simms, was a kind man and was well loved in the community. He was murdered during a holdup at the establishment in the 1950s. The murderer eventually was caught and convicted. Simms's daughter still lives in the area. Today life moves much faster, and there is no such personal connection to stores, as hurried customers zip in and out of the convenience market. (Courtesy Irma Clifton, *Lorton Chronicle*.)

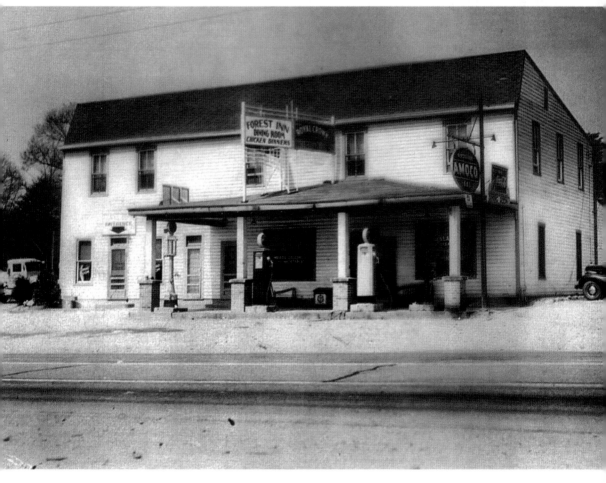

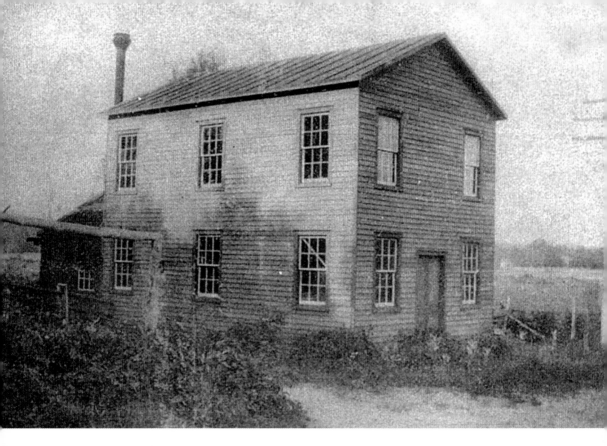

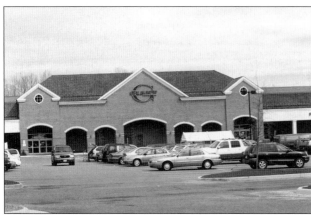

OLD STORE, C. 1911. Mules were used to transport this structure to its new site on Gunston Cove Road when the narrow-gauge railroad tracks were replaced with standard ones. The store later was converted to a house occupied by the O'Neill family, one of the last of which was Emma O'Neill Gaskins. Today's supermarkets have replaced the family markets. (Courtesy Irma Clifton, *Lorton Chronicle*.)

WEBER'S CABINS, 1940S. Many motels, such as Weber's, were located along the Richmond Highway during the 1940s. Families enjoyed a leisurely stop en route from the South to the nation's capital. As the larger freeway system developed, need waned for such establishments along Highway 1. Gunston Plaza now stands where the cabins once entertained guests and contains a grocery store, hobby shops, and a post office. (Courtesy Irma Clifton, *Lorton Chronicle*.)

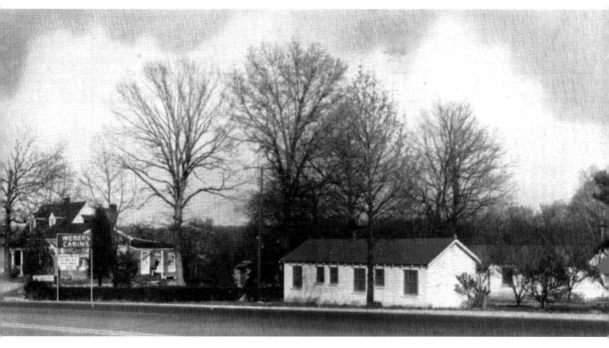

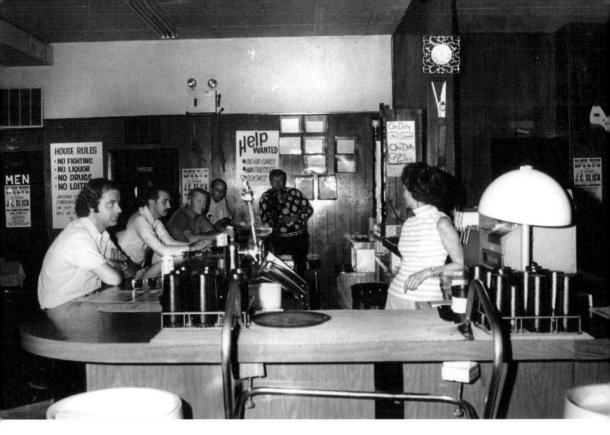

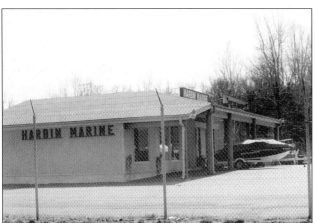

HILLBILLY HEAVEN, 1970s. Operated by Earl Dixon, Hillbilly Heaven was a popular venue for many years, seeing the likes of Bill Hailey and the Comets and Conway Twitty. A far cry from the music scene, Harbin Marine provides entertainment to the daytime crowd as a sports-boat retailer. (Courtesy Norvapics.)

HEIDELBERG, 1974. The Dixie Mill later became the Heidelberg Restaurant, continuing to be a quaint favorite for many locals. As progress marched forward, however, and more housing was built, the need for a localized sewage management system became imperative. The area stepped up to indoor plumbing, and a plant was built where the restaurant once stood. The plant also consumed the property of another restaurant, Bar J. (Courtesy Norvapics.)

41

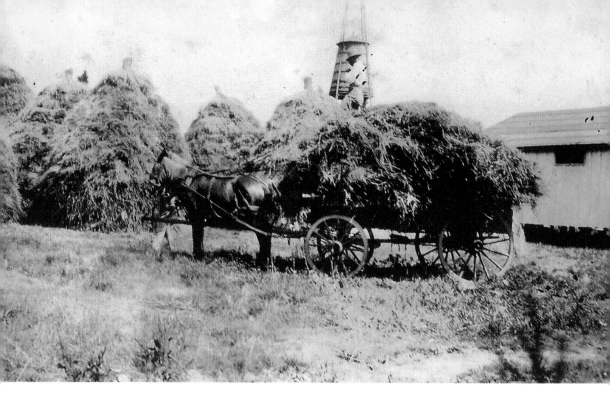

HAY WAGON, 1920. Farming played an important part not only in everyday life, but in the development of commerce in this area. This scene may have been common at private homes and farms well into the 20th century. Farming continued at the prison until the 1980s to support the institution's dairy operations. The silo and barn are quiet reminders of a way of life no longer practiced in Lorton. (Courtesy Gunston Hall.)

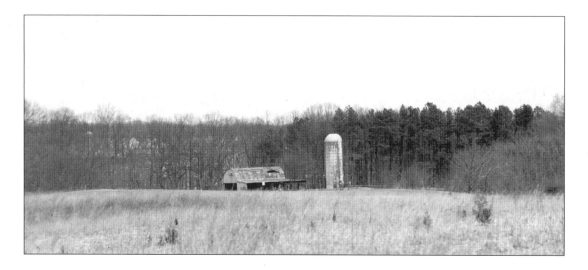

Chapter 4
HOMES

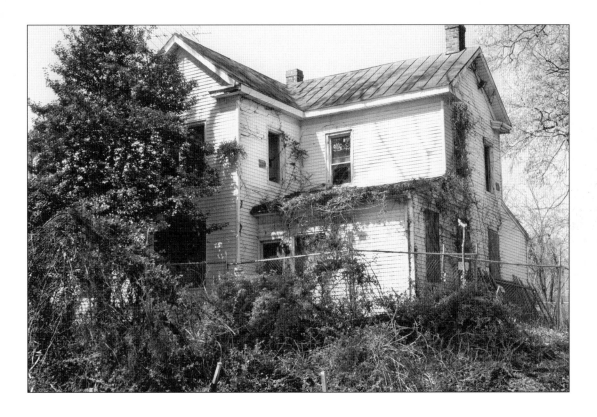

SPRINGMAN HOUSE ON GUNSTON COVE ROAD. This is the last remaining structure from the original town of Lorton. Across the street from it now sits a quick mart, where the old store and original Lorton Post Office once stood.

LAUREL HILL.

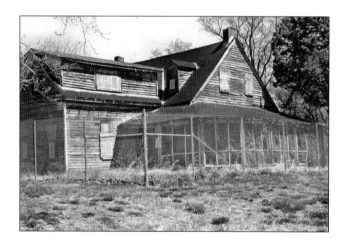

LAUREL HILL, 18TH CENTURY.
Before going off to fight with the
Virginia Militia in 1776, during the
Revolutionary War, Maj. William
Lindsay married Ann Calvert, great-
granddaughter of Cecil Calvert, Lord
Baltimore. The couple made a home
on the plantation called Laurel Hill.
During the prison years, the house
was used as an employee residence
and guest house. (Courtesy Virginia
Room, Fairfax County Library.)

LAUREL HILL, 1977. The property encompasses the remnants of the Lorton Prison Complex, some 926 acres of Fairfax County Park land, and 430 acres of Northern Virginia Regional Park Authority land. The potential of restoring the house is questionable because of its extreme disrepair. Nearby, on Silverbrook Road, there is a housing development named for the plantation, and there is speculation that the community of Lorton will face a name change of the same kind in the near future to remove the stigma long associated with the area from the prison. (Courtesy Virginia Room, Fairfax County Library.)

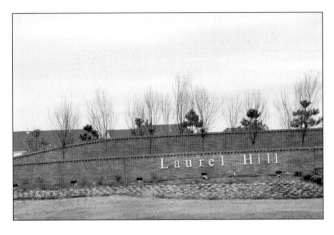

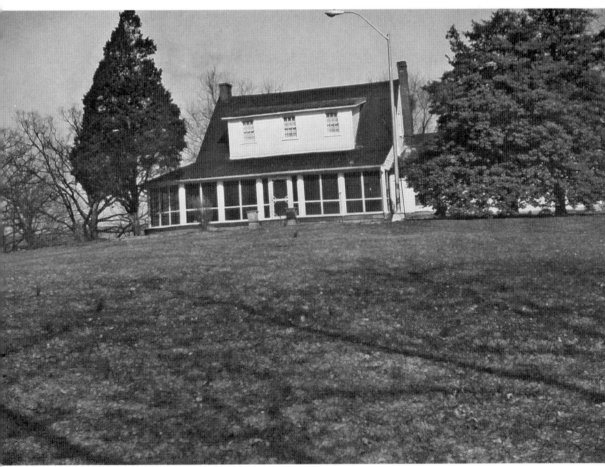

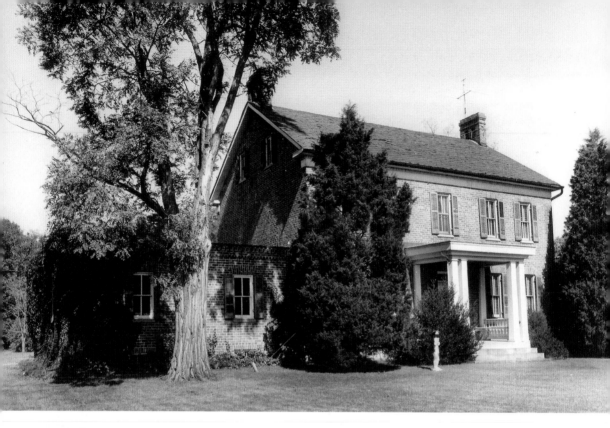

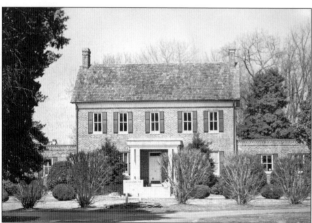

LEBANON, C. 1970. The house was built in 1732 by Edward Bates. It was owned by three generations of men with the same name and was first recorded under the name of Lebanon in Fairfax County records of 1880. Active in the Methodist movement, Bates held meetings in the barn on the property. Among the speakers was Francis Asbury, the first Methodist bishop to be ordained in the United States. The house gained a second story around 1850 and an additional wing around 1900. The wing was moved away from the house in 1942, when a garage was added. During this period, the Bartsches lived here and established an arboretum and wildlife sanctuary. Their legacy lives on, as the house is owned by the Virginia Park Authority and serves as the clubhouse for the golf club in Pohick State Park. (Courtesy Fairfax County Library Virginia Room.)

HUNTINGDON, 1970s. Edward Barry, brother of the last earl of Barrymore, came to Virginia from Ireland around 1720. Barry purchased Huntingdon in 1741. After his death around 1748, his wife waited three years before marrying Edward Washington, of no relation to George Washington. The property then went to the late Barry's son, Edward Jr. After his demise, the property was listed in the *Gazette* as being auctioned on January 16, 1827. Huntingdon did not sell, and in 1828, it was purchased by Isaac Hutton, an Englishman. During the Civil War, the women of Huntingdon were aided by a slave named Tom Bushrod, who provided them with food. In 1965, the great-grandson of Hutton, Benjamin Nevitt, sold the property to Cafritz, a real-estate developer. The property eventually was sacrificed to progress with the development of single-family housing. (Courtesy Virginia Room, Fairfax County Library.)

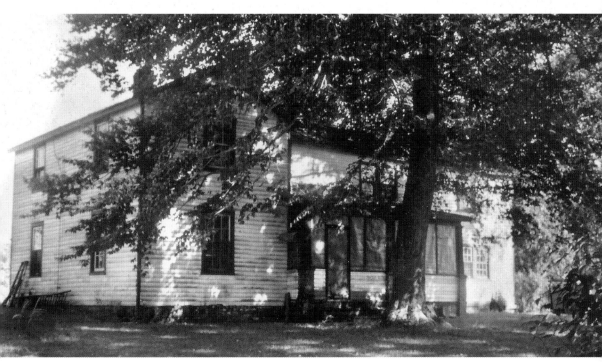

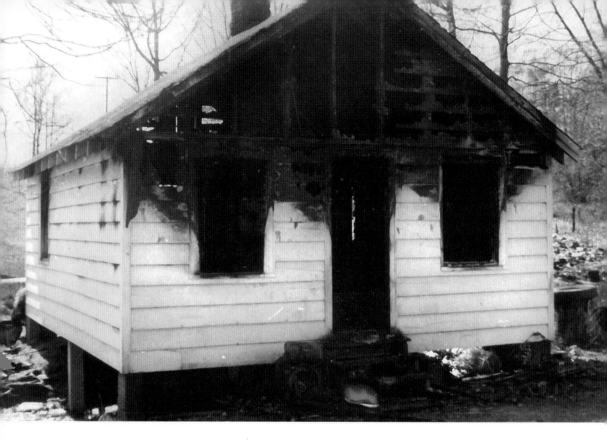

9717 SILVERBROOK, LUDLOW ESTATES, 1960S. Large subdivisions of upper-middle-class homes have sprung from the demise of the rural Lorton. This is among the houses redefining the term "estates." (Courtesy Fairfax County Library Virginia Room.)

9215 OX ROAD, 1970s. No historical documents or books about this structure can be found. It represents a common man's home, original in design and craftsmanship. Once it stood in a rural location. This has been replaced by a larger housing development, as shown in the contemporary photograph. (Courtesy Fairfax County Library Virginia Room.)

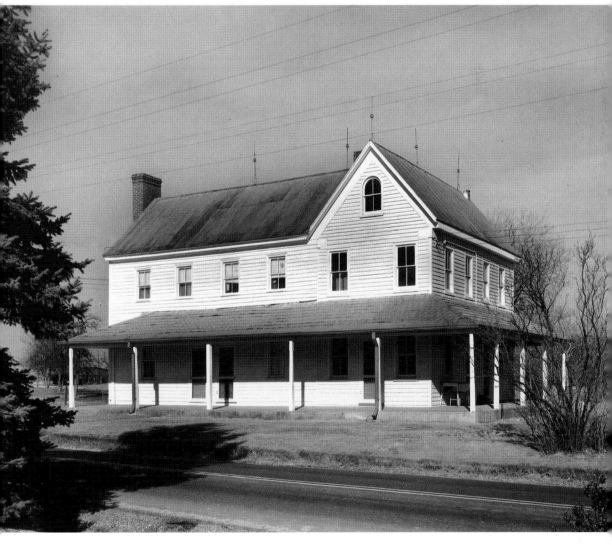

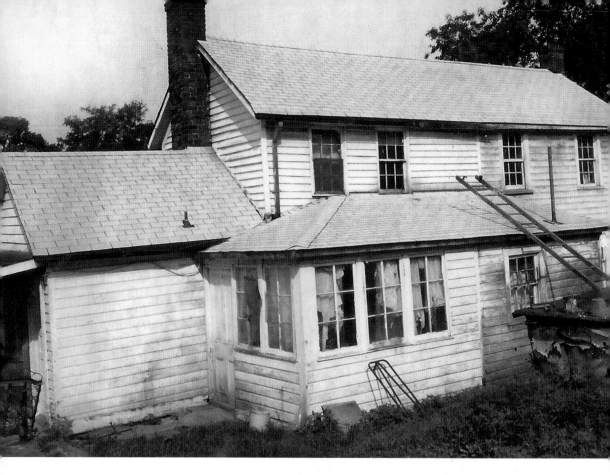

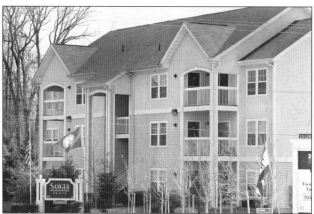

9311 SANGER STREET, 1960s. Sanger Place is one of the many Lorton developments created by KSI Real Estate Developers. It is considered a luxury apartment complex because of its many amenities. The author believes this house once stood where the apartments are, but that is hard to prove, because Sanger Street does not include any odd-numbered addresses. (Courtesy Fairfax County Library Virginia Room.)

BELMONT HOUSE, 1960s. Sources vary regarding when this house was built between 1717 and 1730. The builder likely was carpenter Thomas Simpson. In 1734, Catesby Cocke, a Prince William County clerk, purchased the house. A *c.* 1791 survey connected Lawrence Washington to the home, although his purchase date is uncertain. There is some debate regarding whether Edward Washington ever owned this property, but evidence makes that claim doubtful. The property was sold at auction in 1828 and went through a brief period of unstable ownership. Around 1866, the property was acquired by the Haislip family, which heavily altered the structure. In 1974, George C. Rawlings undertook preserving the house by integrating it into a two-story Colonial-style home. (Courtesy Library of Congress.)

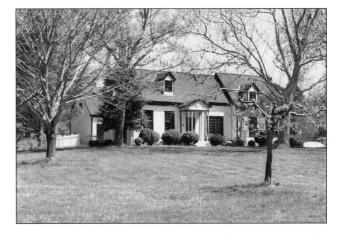

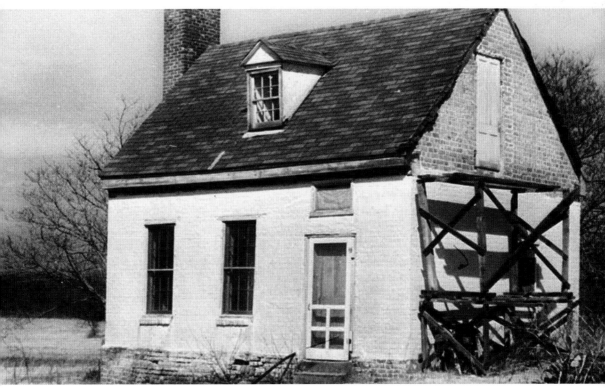

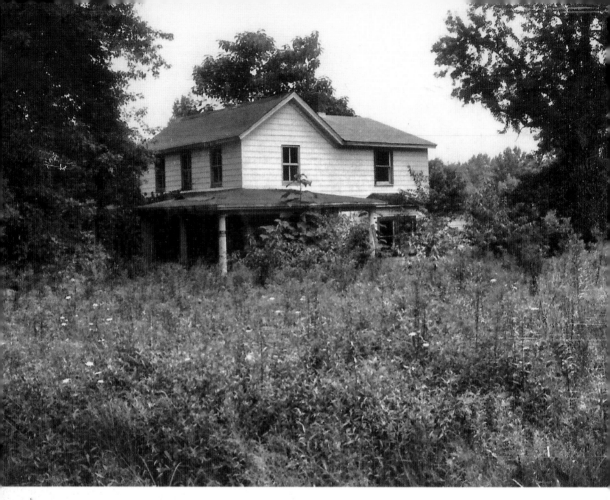

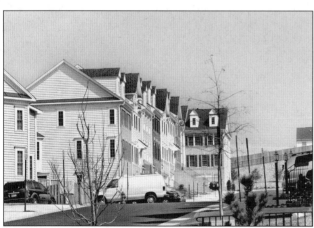

9427 GUNSTON COVE, 1960S. Large farmhouses have been replaced with rows of townhouses just off Gunston Cove Road. No longer an agrarian area, this locale accommodates the commuter lifestyle prevalent today. (Courtesy Virginia Room, Fairfax County Library.)

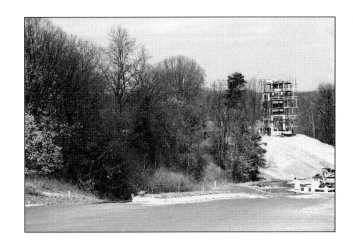

9616 GUNSTON COVE ROAD, 1960S.
Again progress plows on, as many
wonderful old structures such as this
take their long and colorful stories
with them. (Courtesy Virginia Room,
Fairfax County Library.)

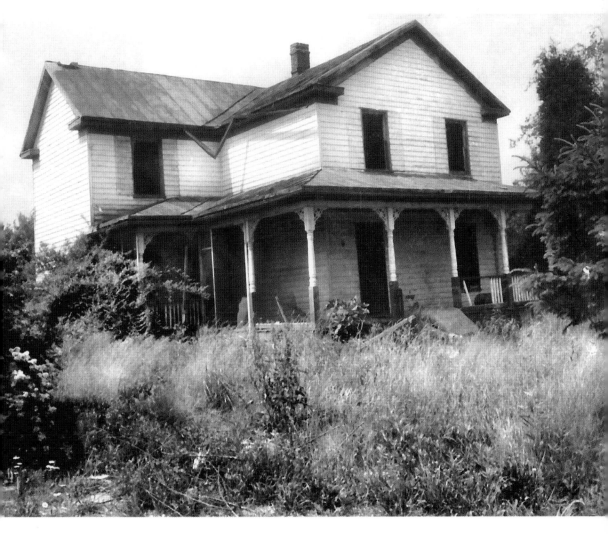

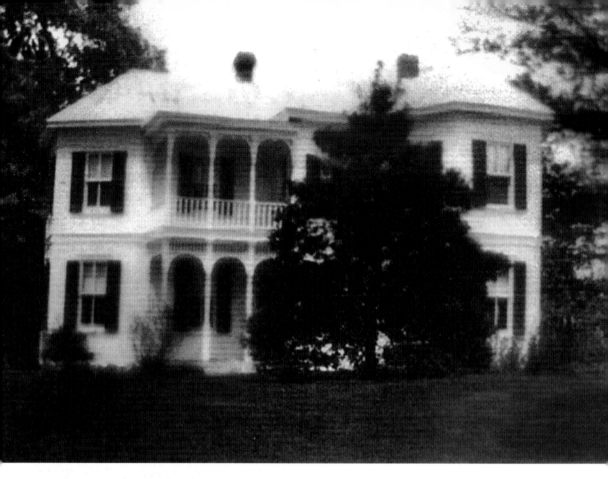

SPRINGMAN HOUSE, C. 1900. Once a graciously groomed home, the Springman House is now barely visible through the overgrowth. It is the last standing structure of the village of Lorton, and the property is listed as open for development. (Courtesy Irma Clifton, *Lorton Chronicle.*)

Chapter 5

PUBLIC WORKS
AND SERVICES

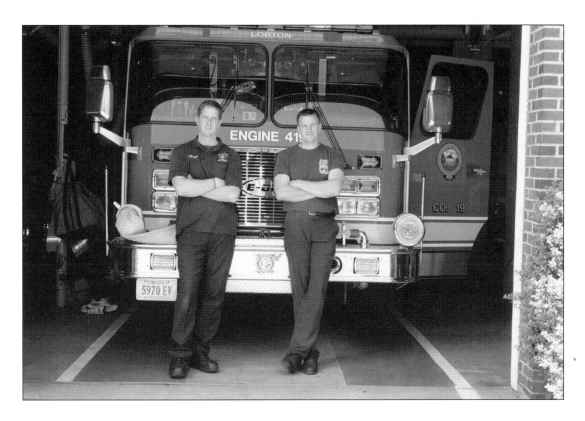

PUBLIC SERVANTS. Firefighter Eric Bartholomew and master technician Robert Upchurch stand in front of Engine 419 at the Lorton Fire House. Both men aided at the Pentagon following the September 11 attacks.

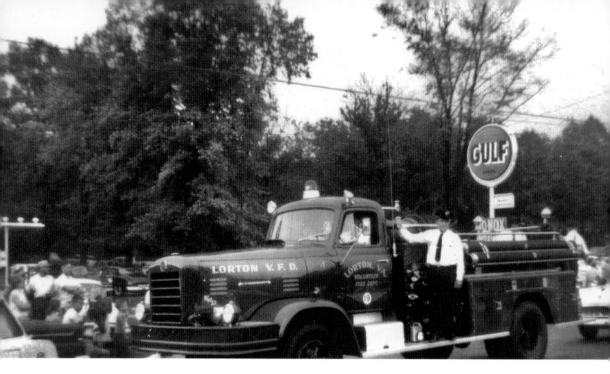

LORTON FIRE TRUCK, 1960s. From the time of parades and—perhaps—one call a day, the Lorton Fire House has grown along with the needs of the community. In 2001, Lorton firefighters played an integral part in reaching beyond this community when they aided in putting out the Pentagon fires on September 11. (Courtesy Eric Bartholomew, Lorton Fire House.)

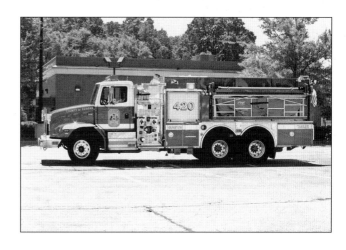

FIRE TRUCK, 1950s. Technology as well as staffing needs have changed since the 1950s. The local stations of Lorton and Gunston are still partially staffed with volunteers and a large balance of career firefighters. (Courtesy Norvapics.)

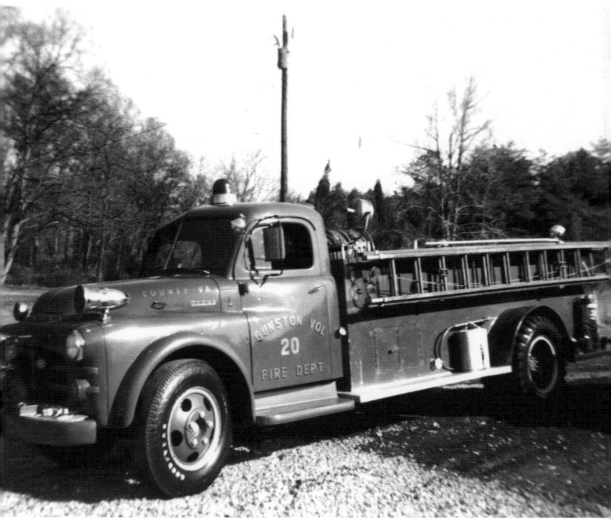

GUNSTON FIRE HOUSE, 1960s.
The Gunston Fire Station, located
on Gunston Road, has steadily
improved its service capabilities.
(Courtesy Norvapics.)

LORTON VALLEY SCHOOLHOUSE, LATE 19TH CENTURY. The elementary school at the Interstate 95 intersection now serves other purposes than education, such as voting and transportation coordination. Before the current structure was built, a one-room schoolhouse existed there. Children and young people gathered in that one building to learn. (Courtesy Irma Clifton, *Lorton Chronicle*.)

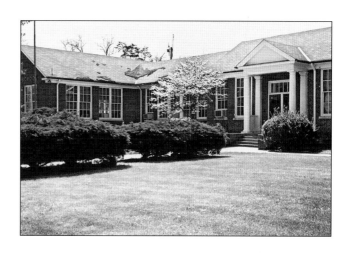

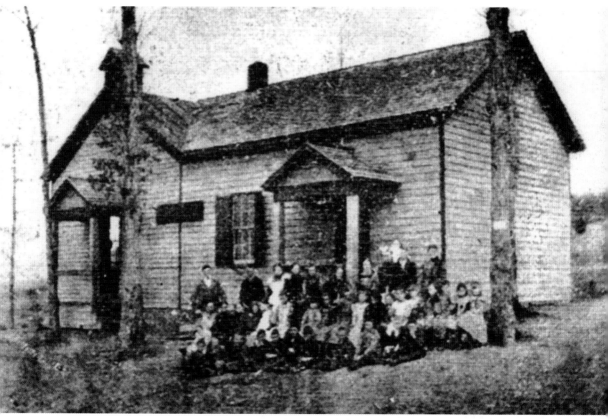

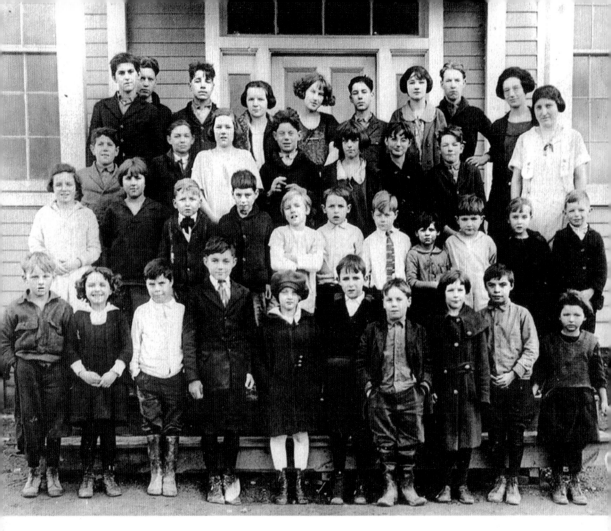

SCHOOL KIDS, 1924. Children of all ages gathered in one schoolhouse for learning during the early 20th century. In 2004, a new high school was built on part of the old prison property and neared completion in 2005. (Courtesy Irma Clifton, *Lorton Chronicle*.)

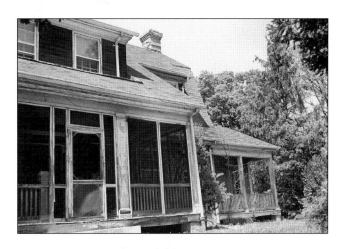

DOCTOR'S HOUSE, C. 1931.
Dr. Frank W. Hornbaker was the Occoquan town physician. When the prison opened, he served it as well while maintaining a private practice. The family's home was cared for, in part, by prisoners. One inmate they were particularly fond of tended gardens. (Courtesy Martha Roberts, Historic Occoquan, Inc.)

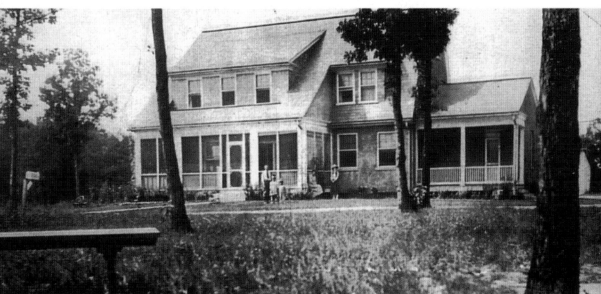

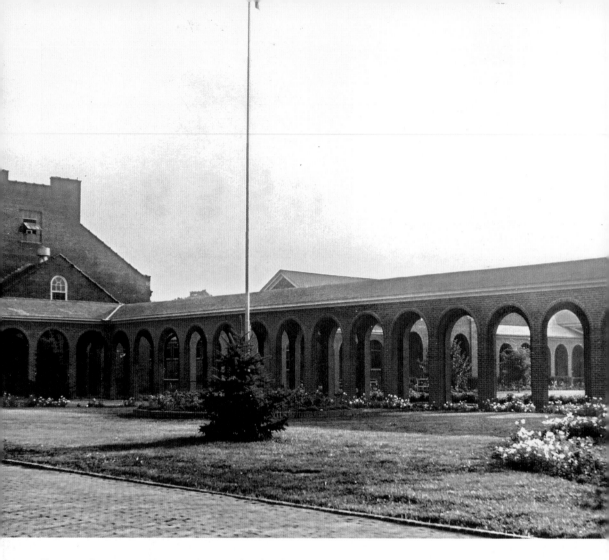

PRISON ARCADES, 1966. In 1910, under the direction of Teddy Roosevelt, 1,155 acres were acquired for building a new prison facility. An attempt to incorporate progressive ideals into the prison included features such as its open-air design. Prisoners built the arcades out of brick made at the on-site kiln complex along the Occoquan River. As part of the reuse plan, the grounds of the prison are now called Laurel Hill and are open for recreational baseball teams. (Courtesy Fairfax County Library Virginia Room.)

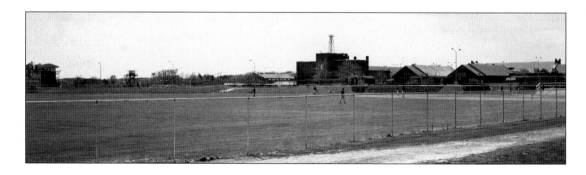

LORTON REFORMATORY, 1966.
When Teddy Roosevelt opened the
new prison, he envisioned a place
where prisoners could be rehabilitated.
The prison reformatory, designated
for serious offenders, opened in 1916.
Various parts of the prison complex
are now undergoing many changes
and face-lifts. (Courtesy Fairfax
County Library Virginia Room.)

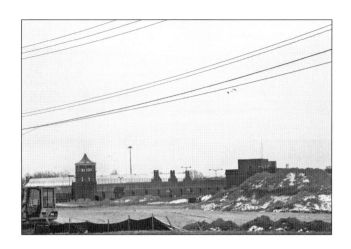

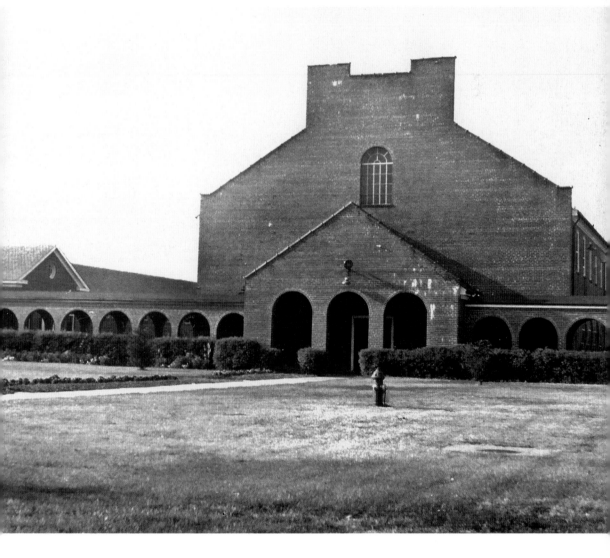

FORCIBLE FEEDING THROUGH THE NOSE OF WOMEN SUFFRAGIST PRISONERS.

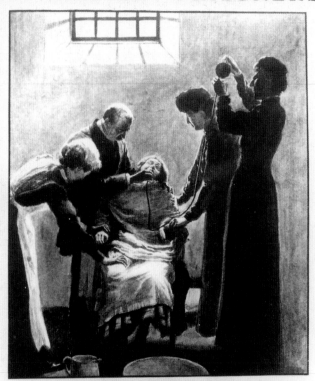

This system is practised by our prison authorities owing to Women Suffragist Prisoners adopting the "Hunger Strike," which they have done, not to escape imprisonment, but to obtain the treatment previously accorded to political prisoners. 'Woman Suffrage" is undoubtedly a political movement.

FORCE FEEDING, C. 1918, AND OCCOQUAN DORMS, 1920S. About 168 women suffragist demonstrators were detained at the medium facility on Ox Road, which now is the water plant. Those women suffered many indignities, including force feeding. The open-air prison featured dorms rather than cell blocks. It was here that the women passed part of their time from June to December 1917. (Courtesy Fairfax County Library Virginia Room.)

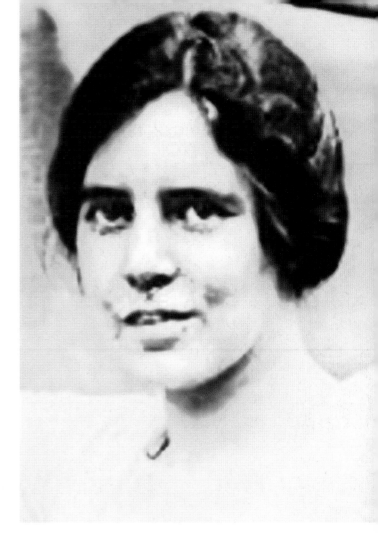

Alice Paul, *c.* **1918, and Woman Voter, 2004.** Alice was part of the suffrage movement in England before organizing protests and rallies back home in America. She was imprisoned three times, along with many other women, including time at Occoquan. Because of their efforts, women today are free to exercise the right to vote.

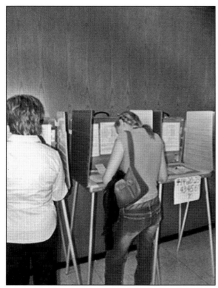

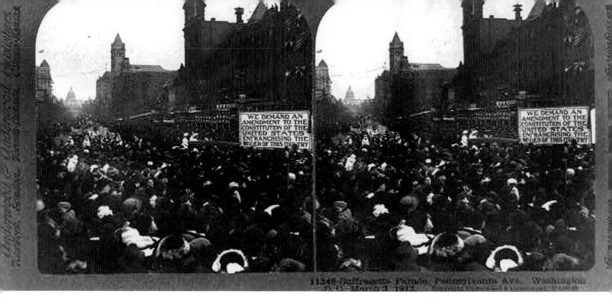

SUFFRAGISTS IN WASHINGTON, D.C., C. 1918, AND OCCOQUAN WORKHOUSE, 1920S. All American women owe a debt of gratitude to these bold and brave women who marched and picketed for the vote. The 72-year struggle culminated in 1920, when the 19th Amendment gave women the right to vote. Sending suffragists to the workhouse, a medium-security facility, stirred a controversy, as it was viewed an extreme sentence for blocking the White House sidewalks in a peaceful picket. The building is now gone, and the location houses the new water plant. (Courtesy Library of Congress and Fairfax County Virginia Room.)

HOUSE WITH WELL, 1960s. In the old days, a well was a mark of a good property. In Lorton, the old days extended to just a few decades ago for some. Hence, three water plants have serviced the area, two in Lorton and one in Occoquan. These are being replaced by the Griffith facility, comprised of a number of buildings on the space once occupied by the Lorton Medium Security Prison. The gate was constructed from old prison bricks, many of which were manufactured by prisoners along the Occoquan River in the early 20th century. (Courtesy Fairfax County Library Virginia Room.)

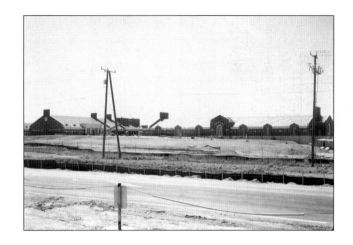

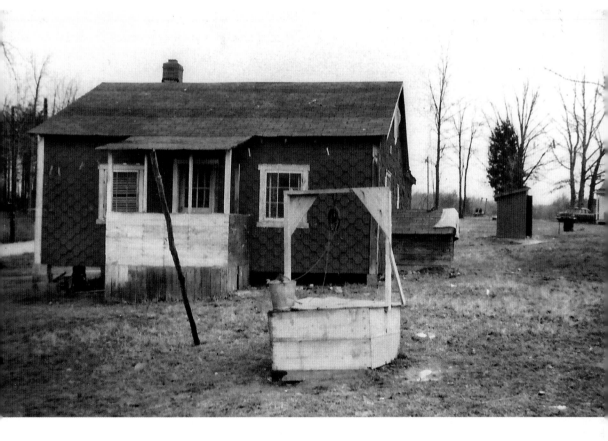

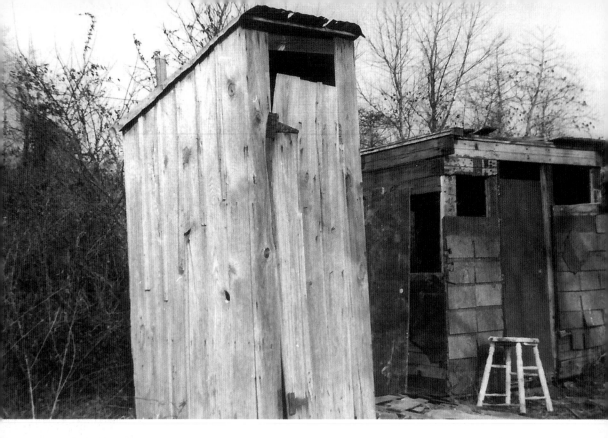

OUTHOUSE, C. 1970. Lorton had many outdoor waste facilities before the sewage plant was built. Most of the outhouses have been torn down but just in the past few decades. (Courtesy Fairfax County Library Virginia Room.)

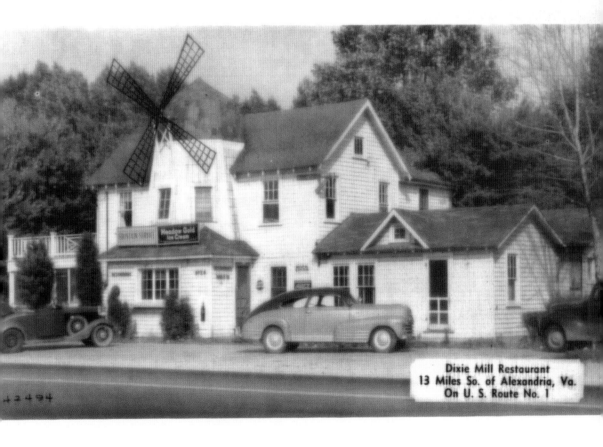

DIXIE MILL, C. 1940s. The Dixie Mill later became the Heidelberg Restaurant, which was, in turn, replaced by the sewage plant. Rumor has it that before it became the respectable restaurant, it was a house of ill repute. (Courtesy Norvapics.)

Dixie Mill Restaurant
13 Miles So. of Alexandria, Va.
On U. S. Route No. 1

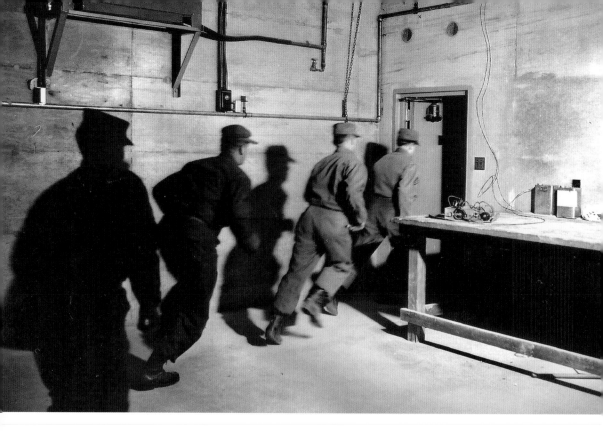

MEN RUNNING FROM BARRACKS, 1960s. When Dwight D. Eisenhower came into office, he moved to use nuclear warheads on anti-aircraft missiles. The new weapon was called Nike-Hercules. Lorton became the prototype site for the conversion. The army beefed up security, adding fences and guardhouses and assigning four-man police detachments with guard dogs. Drills were a common practice for the men who worked here. In 1973, the decision was made to close the site. The housing now sits abandoned and overgrown with weeds, but the fences still warn passersby to keep out. (Courtesy National Archives.)

NIKE MISSILE SITE, 1960s. During World War II, the American military began experimenting with missiles and rockets in response to the German rocket program. In the early 1950s, due to the cold war, the army endorsed a nationwide surface-to-air missile defense program, abbreviated as SAM. In October 1953, the army acquired 80 acres from the Lorton Prison for a SAM site. Fairfax County's adaptive reuse program has transformed the former missile site into a launch pad of a different nature. In 2005, the 250-acre golf course was nearing completion. (Courtesy National Archives.)

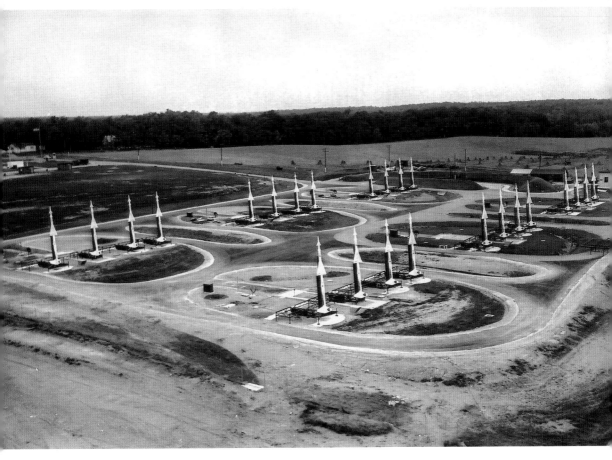

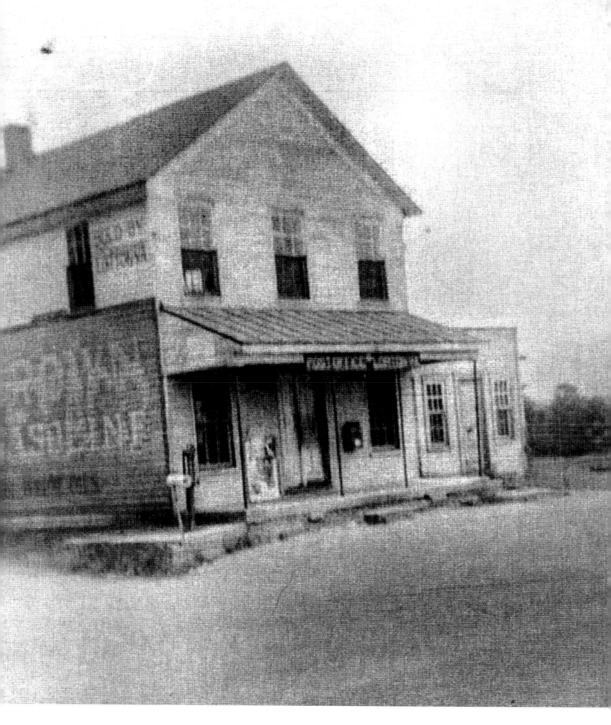

OLD POST OFFICE, C. 1910. This is the building in which Joseph Plaskett had his store when he established the post office and named the community Lorton after his family home in England. (Courtesy Irma Clifton, *Lorton Chronicle.*)

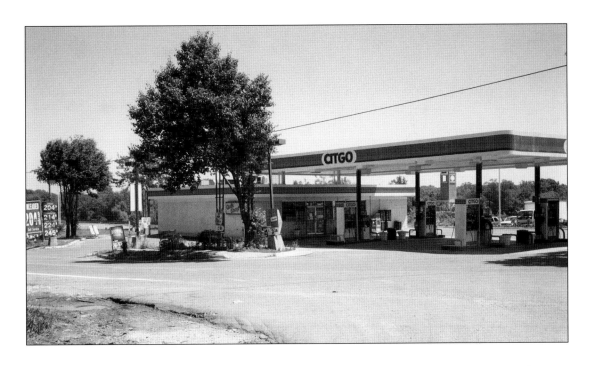

CITGO AND POST OFFICE. The Citgo is located on Gunston Cove Road where the old Plaskett store and post office once stood. The present post office is located in Gunston Plaza on Route 1, the Old Richmond Highway.

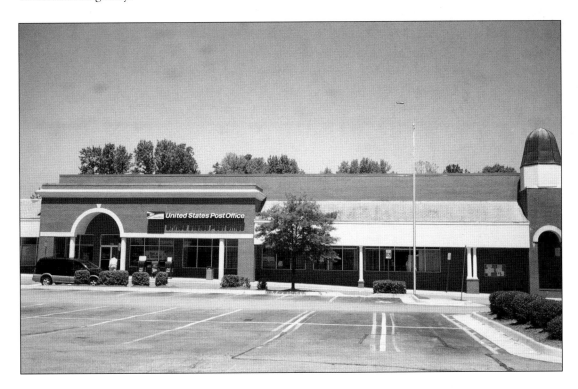

MASON NECK, 1965. Now a state park and national wildlife refuge, Mason Neck primarily was used for logging in the past. The use of the pesticide DDT and the removal of mature pines and other trees led to the decline of the bald eagle in the region. Today animals enjoy protection under the park services, which ensures they will be around for future generations to enjoy. (Courtesy Fairfax County Library Virginia Room.)

DREDGING MASON NECK AT GUNSTON HALL, 1916. Gunston Hall owner Louis Hertle had a canal dug on the banks of the Potomac. Some of the first visitors to use the passage were J. P. Morgan and his family on their yacht, *Corsair*. In 1965, the Mason Neck Conservation Committee was formed after two bald eagles were spotted on the neck. After several threats, including a beltway, an airport, and a sewer line, Mason Neck State Park was established and opened to the public in 1985. (Courtesy Gunston Hall.)

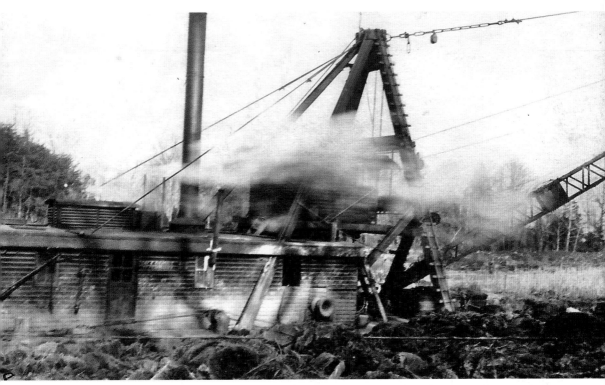

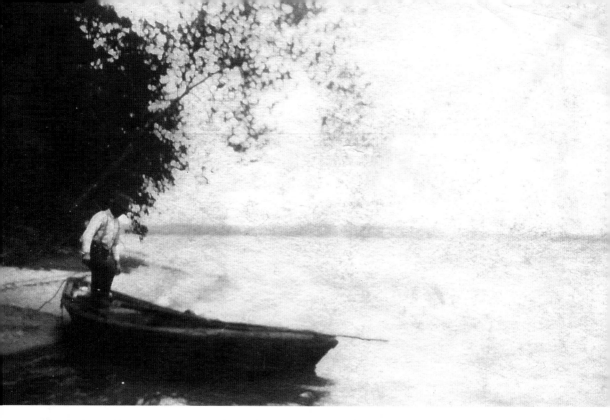

FISHING, 1916. Pohick is believed to be the Algonquian word for "water place." For centuries, people have enjoyed fishing in this picturesque setting. Between 1961 and 1974, the Virginia Regional Park Authority acquired the 1,002 acres that make up the park. The land still is a popular spot for fishing as well as for golfing and camping. (Courtesy Gunston Hall.)

Chapter 6

TRANSPORTATION

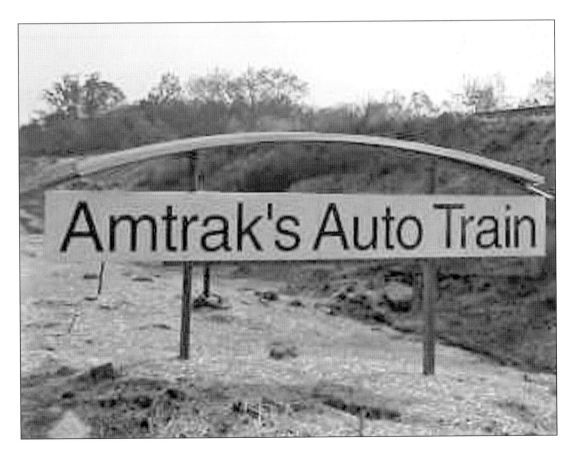

AMTRAK AUTO TRAIN SIGN, 2005. The auto train provides non-stop service between Lorton and Sanford, Florida. Passengers can have their cars loaded and conveniently arrive at their destination ready to go.

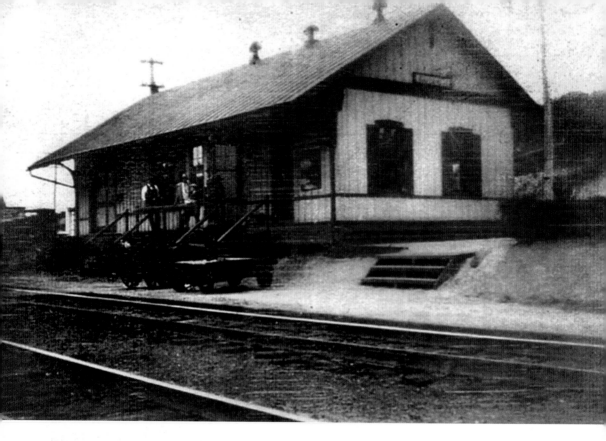

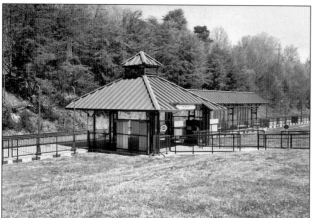

LORTON STATION, C. 1900. There are many stories associated with the train at Lorton Station. Probably the most poignant involved George A. Malcolm, a 22-year-old head teacher at Lorton Valley School and a volunteer Fairfax County deputy sheriff. On April 6, 1905, an immigrant worker, Joseph Leanto, was accused of harassing one of the young female students. During a pursuit that followed, Leanto and Malcolm both were shot and put on trains bound for doctors in Washington, D.C. A note was pinned to Leanto's clothing, reading, "Please notify this man's friends in Washington. If he gets well, let the sheriff of Fairfax County know, as he is wanted." Ironically, Leanto and Malcolm were placed in the same room and both died, an hour apart, on the evening of April 7, 1905. (Courtesy Irma Clifton, *Lorton Chronicle*.)

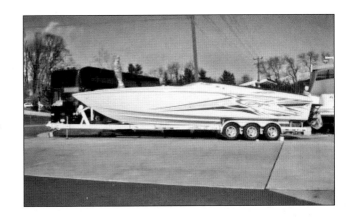

D.C. Wharf, 1839, and Powerboat. Boats like this transported goods from the ports of Occoquan and Colchester to D.C. and beyond. Boating now has a much more recreational purpose on these waterways.

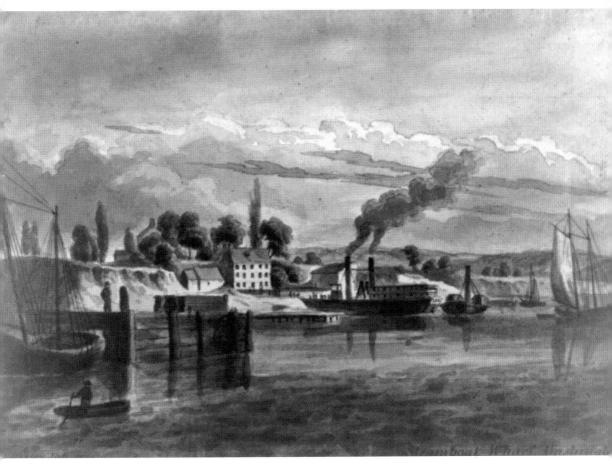

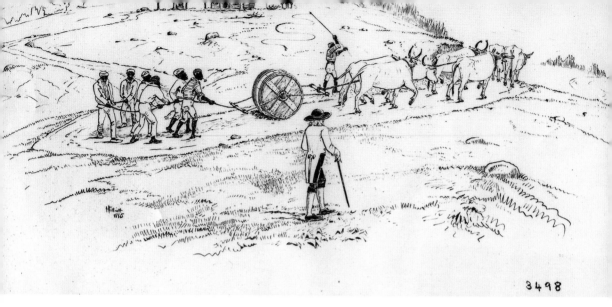

3498

ROLLING ROAD, 18TH CENTURY.
To transport tobacco to the wharves and to market, farmers would place it in a hogshead barrel pulled by a team of oxen. The trail they traveled was called the Rolling Road. Not much commercial traffic is seen today on Rolling Road, but it is still well traveled and an important link between communities. (Courtesy Virginia Room, Fairfax County Library.)

DIRT ROAD, 1940S, AND GUNSTON COVE ROAD AT ROUTE 1. With all of the busy roads and freeways in Lorton today, it is hard to fathom that just a couple of decades ago, this was how the whole area looked. This busy corner was where the Lebanon school was located back when children used to walk small country roads to school. (Courtesy Library of Congress.)

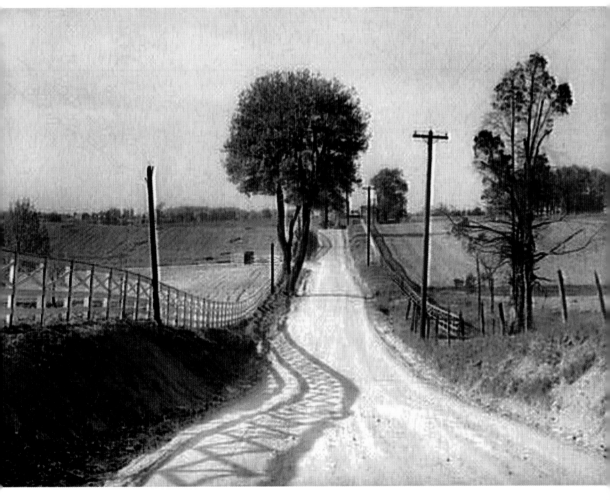

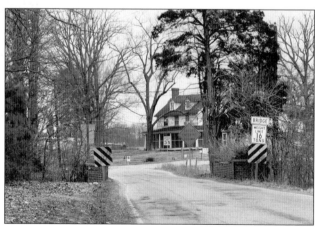

PRISON BRIDGE, 1970s. Few scenes have remained unchanged in Lorton. This one-lane bridge on Furnace Road looks as it did in decades past. Surely it sees many more vehicles now, however, as the population continues to grow. (Courtesy Fairfax County Library Virginia Room.)

GUNSTON COVE BRIDGE, 2005.
The bridge was built 55 years ago
to allow local traffic to cross the
CSX Railroad tracks, linking the
two portions of Gunston Cove
Road. It was closed December 15,
2004, because of erosion of the
embankment, which was undermining
a pier foundation. The fate of the
bridge is yet to be determined.

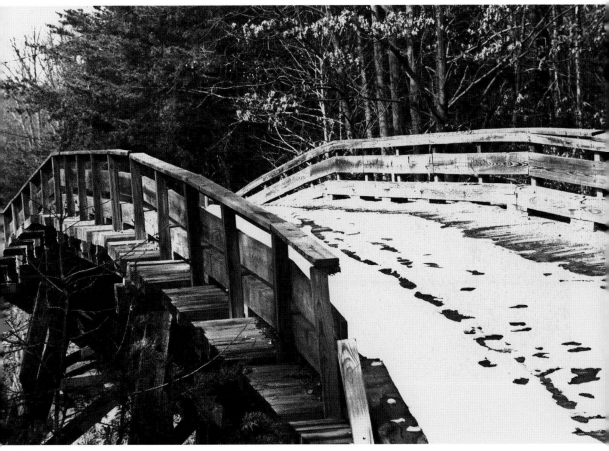

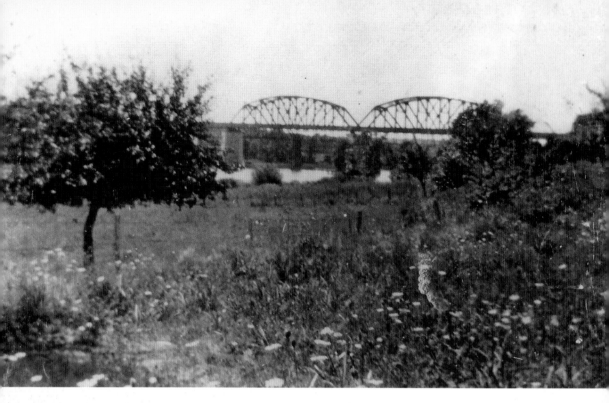

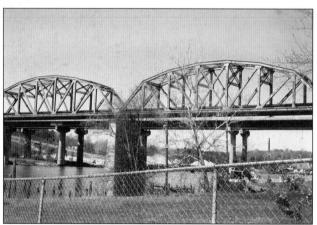

COLCHESTER TRAIN BRIDGE, 1923.
In March 1871, H. K. Bradshaw was awarded the contract to build a bridge for the new railway from Alexandria to Fredericksburg. Two stone footings from this first bridge are still in use. Various improvements have been made since the original bridge was constructed, making it still useful today. (Courtesy Fairfax County Library Virginia Room.)

LORTON ROAD BRIDGE, 1918. Spanning a small creek, this bridge was in service until the 1950s. Its replacement is now undergoing construction, as the road widens to accommodate the growing number of commuters living in Lorton. (Courtesy Fairfax County Library Virginia Room.)

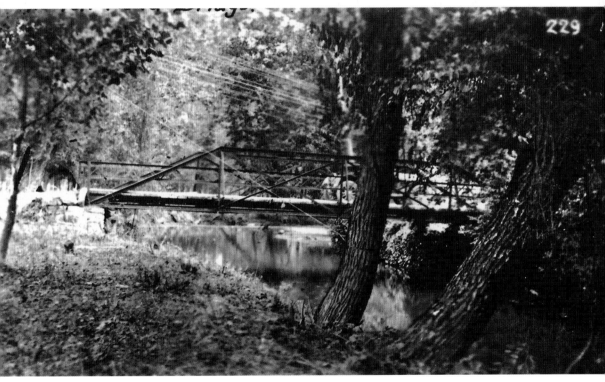

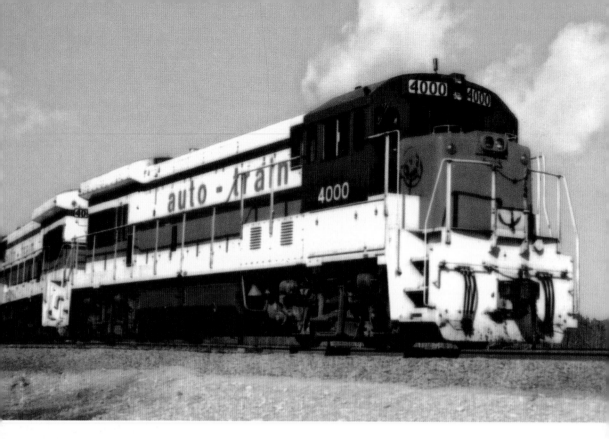

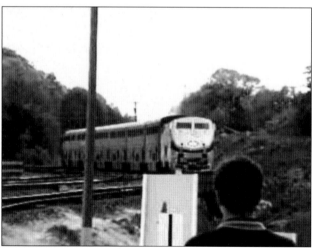

AUTO TRAIN, 1970s. The Amtrak auto train is a great assistance to travelers wishing to take their personal automobiles with them. To facilitate the growing population, the station has expanded into a stylish and modern facility. (Courtesy Norvapics and trainweb.com.)

Chapter 7

GUNSTON HALL

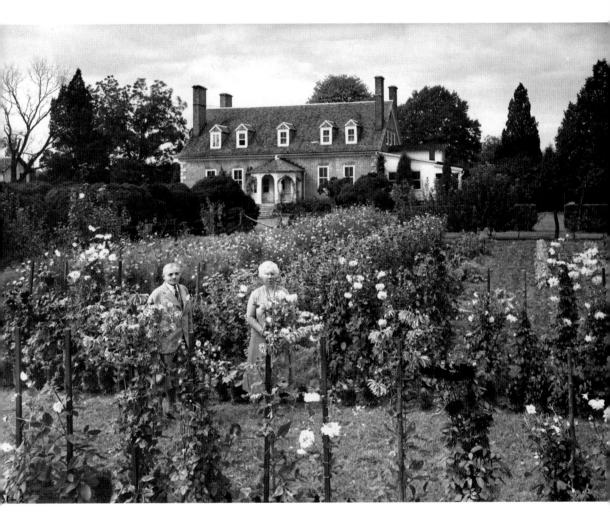

THE HERTLES IN THEIR GARDEN, 1940s. The Hertles were the last owner/residents of Gunston Hall. They entertained many distinguished leaders from Washington, D.C. The original owner, George Mason, also entertained many of our nation's leaders, including George Washington. Mason was the author of the Bill of Rights, which was penned at Gunston Hall. No longer a private home, the site is now open to the public for tours. (Courtesy Gunston Hall.)

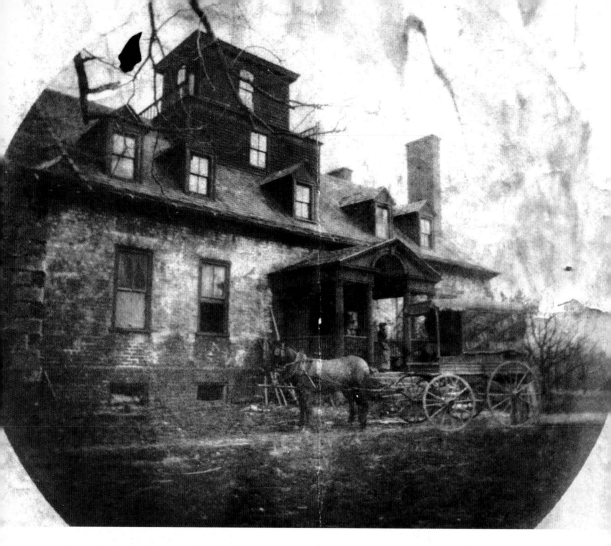

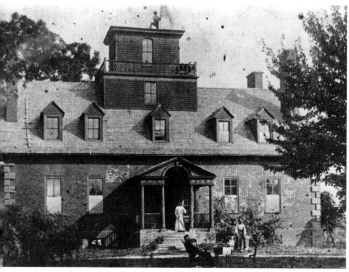

CARRIAGE, *c.* 1890, AND HOUSE, *c.* 1900. At some point prior to the 1890s, an addition was made to the top of the house. It is seen in both of these photos from the period during which the house was owned by Col. Edward Daniels, editor of the *Richmond Journal* and purported friend of President Grant. It was sold in 1891 to Joseph and Emma Specht. Joseph was the proprietor the Famous Clothing Company of St. Louis. (Courtesy Gunston Hall.)

PAUL KESTER, VAUGHN KESTER, AND PAUL WILSTACH, C. 1910.
Kester purchased the house from Specht in 1907. Many artists visited the house during this period, as both Kester brothers were notable writers. Paul is credited with 14 plays, including Broadway shows. Vaughn was a journalist and novelist who wrote a 1911 best seller, *The Prodigal Judge.* Wilstach was a nearby neighbor. He also was a playwright and wrote a number of noteworthy historical pieces. (Courtesy Gunston Hall.)

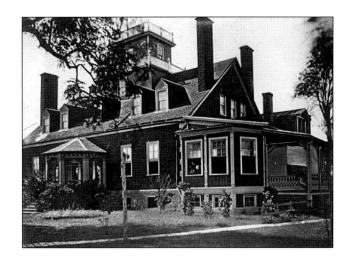

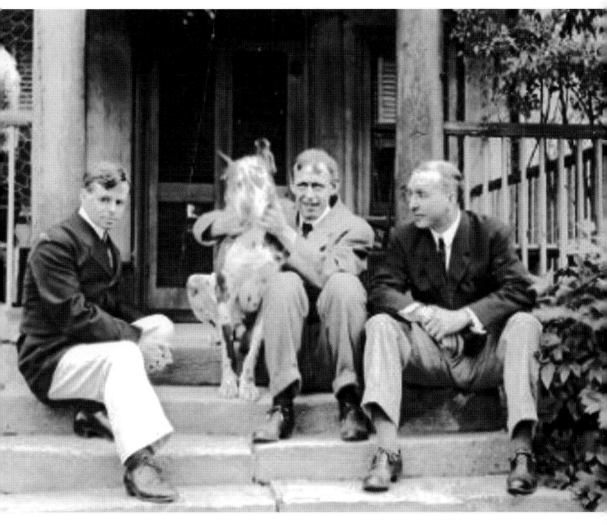

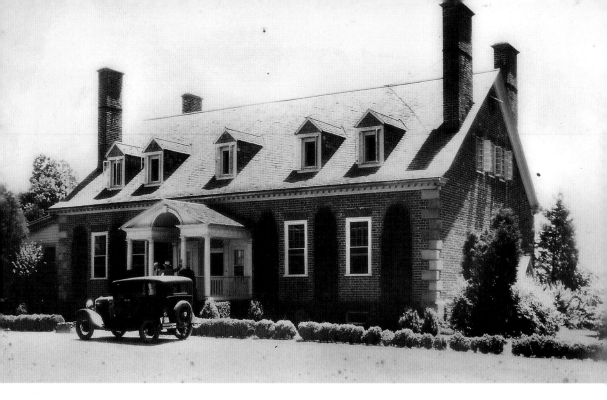

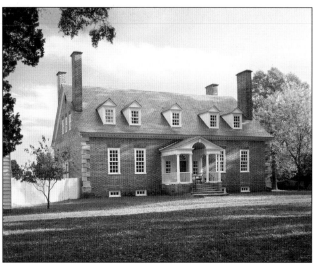

HOUSE FACADE, 1932. In 1912, the property passed hands once again. Louis Hertle became the last private owner of the property. The upper-floor addition was removed, and the house was made more in keeping with its original design. Many high-profile people, including presidents, visited Gunston during the Hertle years, which encompassed the 1930s. (Courtesy Gunston Hall.)

SPECHT GARDEN HOUSE, C. 1900.
The Spechts built a rather unusual
structure in the garden. It was not
their only unusual activity at Gunston.
They tried to open a religious cult
here in association with Dr. Granby
Stanton Howard, who thought he was
half Christ and half Buddha. Unlike
the garden house, the cult never
came into fruition. Today, the only
house seen from the garden is the
main house, as the property has been
returned to how it likely appeared
during the George Mason days.
(Courtesy Gunston Hall.)

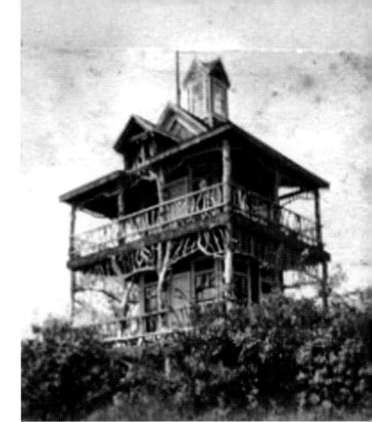

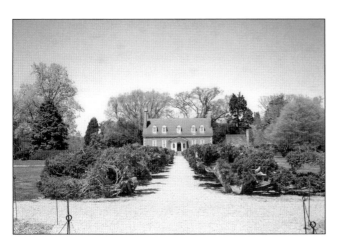

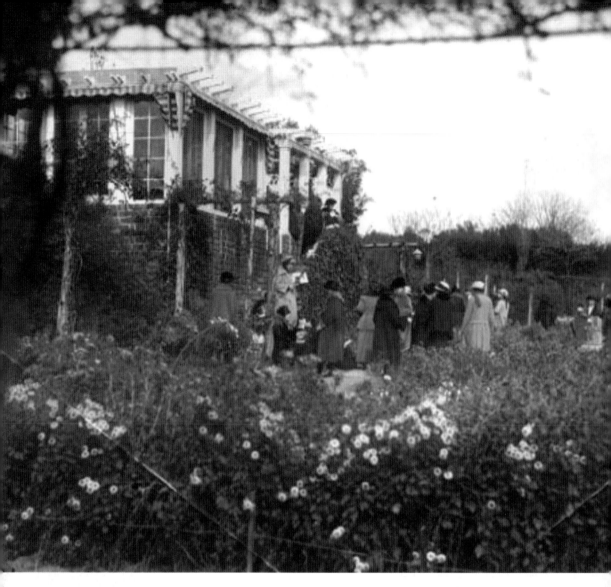

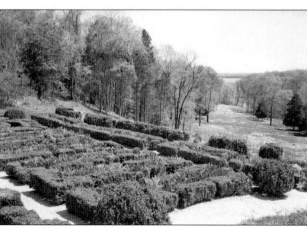

HERTLE GARDEN, 1930s. The Hertles built a much different, open-air garden house to replace the Specht house. The garden was first put in by George Mason and was an integral part of each owner's life. Visitors to the site can still take in the breathtaking view of the Potomac that generations have enjoyed. (Courtesy Gunston Hall.)

OVERSEER'S HOUSE, 1917. This building was relocated from just outside the main house to another part of the property. It is now used by overseers of a different nature, as it is a residence for park employees. Unidentified riders enjoy a rest outside the house in its early location. (Courtesy Gunston Hall.)

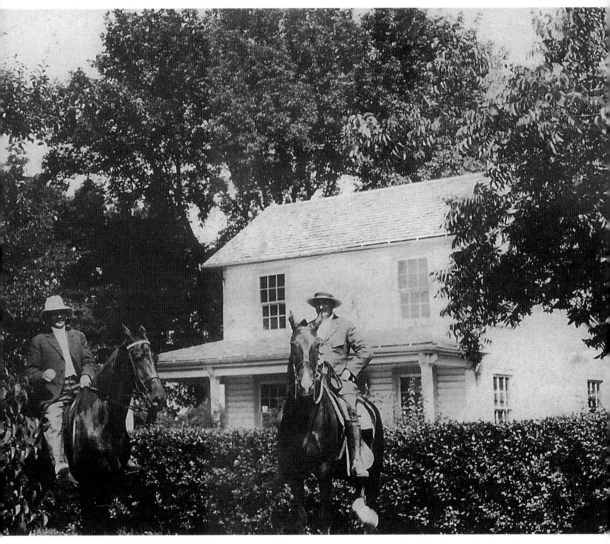

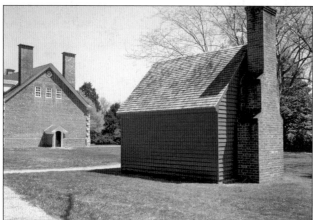

OVERSEER'S HOUSE, C. 1920. In consideration of restoring the property to its appearance during George Mason's residency, the overseer's house was moved and replaced by a schoolhouse representing one in which the Mason children would have studied. The building was constructed based on drawings from that era. (Courtesy Gunston Hall.)